ODD IS ART

Executive Vice President, Intellectual Property Norm Deska
Senior Director of Publishing Amanda Joiner

Editorial Manager Carrie Bolin
Project Editor Jordie R. Orlando
Designers Mary Eakin, Luis Fuentes, Adam McCabe
Reprographics *POST LLC

Special thanks to the Ripley Entertainment Archives
Department for their assistance in gathering materials and
information for this book.

ISBN 978-1-60991-206-2 (US) | ISBN 978-1-78475-969-8 (UK)
Library of Congress Control Number: 2017963438

For information regarding permission, write to
VP Intellectual Property
Ripley Entertainment Inc.
Suite 188, 7576 Kingspointe Parkway
Orlando, Florida, 32819
publishing@ripleys.com
www.ripleybooks.com

Manufactured in China
in January 2018
1st printing

PUBLISHER'S NOTE
While every effort has been made to verify the accuracy
of the entries in this book, the Publishers cannot be held
responsible for any errors contained in the work. They
would be glad to receive any information from readers.

Young Arrow
20 Vauxhall Bridge Road
London SW1V 2SA

Young Arrow is part of the Penguin Random House
group of companies whose addresses can be found at
global.penguinrandomhouse.com.

Ripley Entertainment Inc. has asserted the right to be
identified as the author of this Work in accordance
with the Copyright, Designs and Patents Act 1988.

First published in Great Britain in 2018 by Young Arrow
www.penguin.co.uk

A CIP catalogue record for this book is available from
the British Library.

ODD IS ART

RIPLEY ®

PUBLISHING

a Jim Pattison Company

"Some of the most wonderful things in the world will seem dull and drab unless you view them in the proper light."

– Robert Ripley

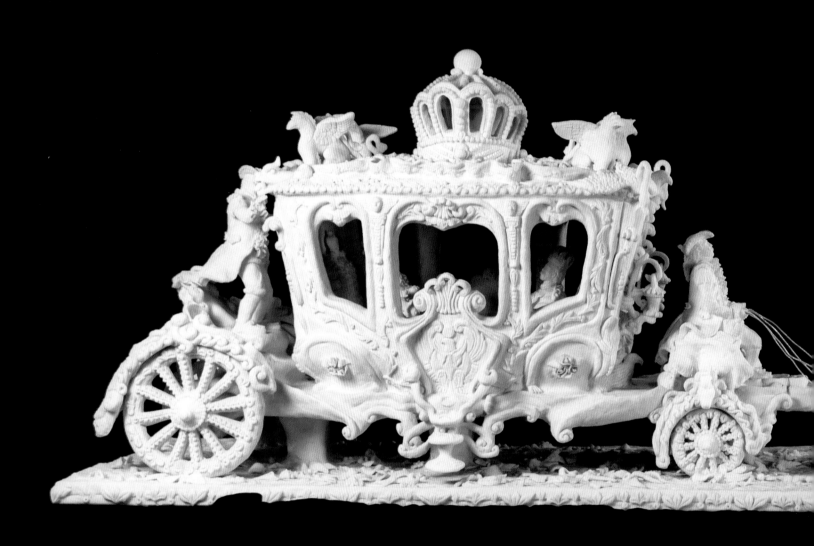

THE ROYAL CARRIAGE ASH ELSAYED

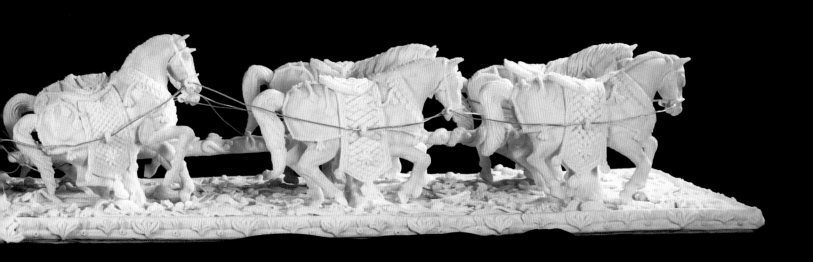

NEW YORK CITY, NEW YORK, UNITED STATES

MADE FROM A MIXTURE OF CORNSTARCH, SALT, AND WATER.
8 x 2.5 x 1.75 FT (2.5 x 0.8 x 0.5 M), 300 LB (136 KG)

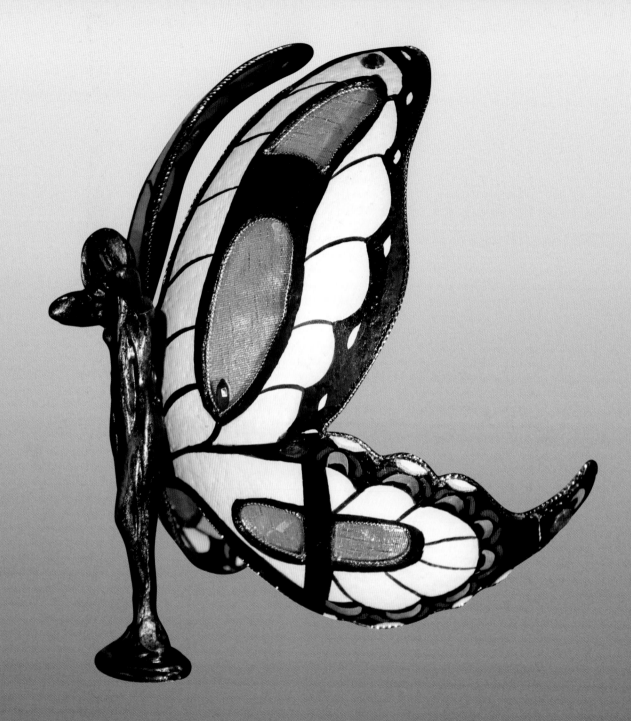

OSTRICH EGG FAIRY PAT BEASON

CARLSBAD, NEW MEXICO, UNITED STATES
A FAIRY'S WINGS CARVED FROM A SINGLE OSTRICH EGG AND PAINTED IN THE STYLE
OF AN EASTERN TIGER SWALLOWTAIL BUTTERFLY. 8 x 6 IN (20.3 x 15.2 CM)

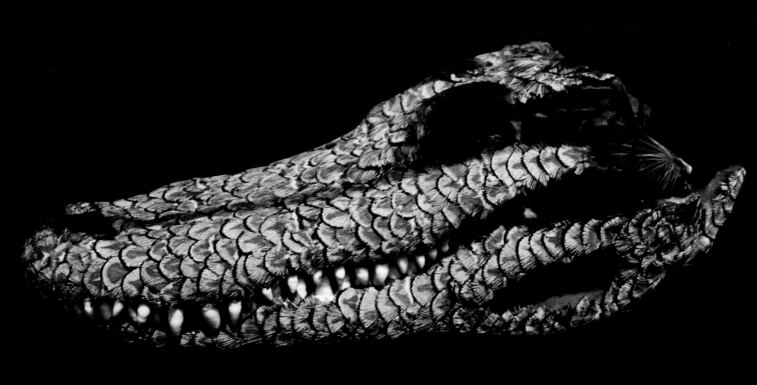

FEATHERED SKULL

KEY WEST, FLORIDA, UNITED STATES
ALLIGATOR SKULL ADORNED WITH PLUMAGE FROM A PEACOCK.

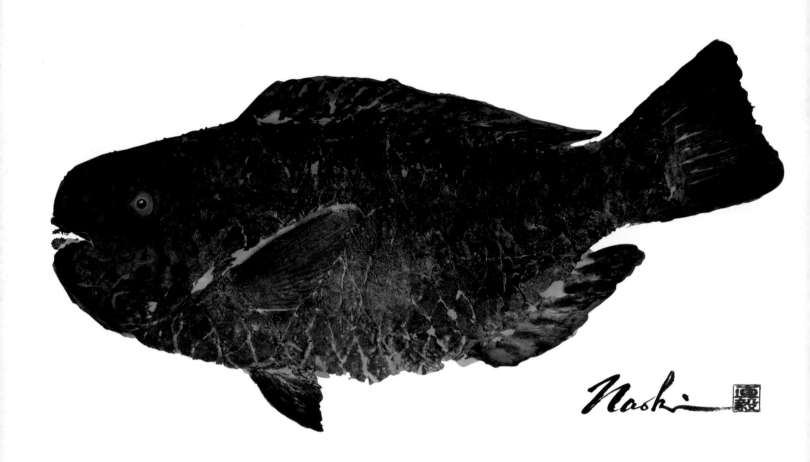

UHU ULIULI NAOKI HAYASHI

KANEOHE, HAWAII, UNITED STATES
A TRADITIONAL JAPANESE ART FORM KNOWN AS *GYOTAKU*,
THE ARTIST PAINTS THE FRESHLY CAUGHT FISH AND THEN STAMPS IT ONTO A CANVAS.

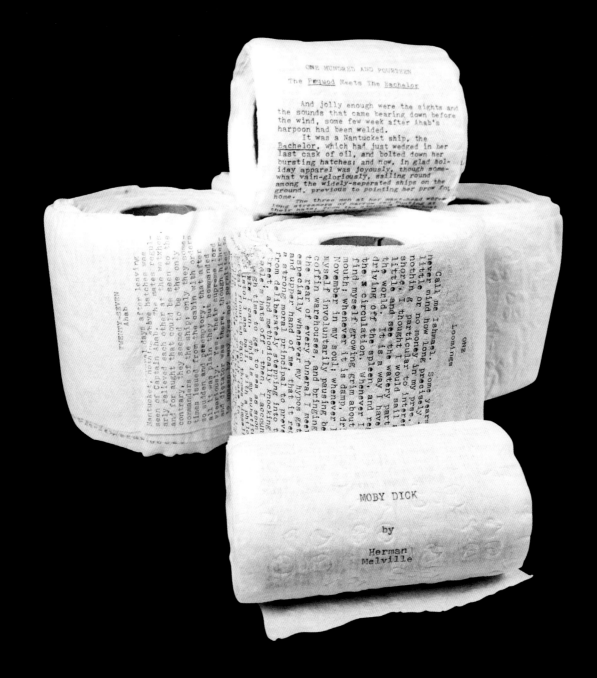

BATHROOM READING DENNIS MALONE

PALM SPRINGS, FLORIDA, UNITED STATES
HERMAN MELVILLE'S 1851 NOVEL *MOBY DICK* TYPED ONTO SIX ROLLS OF TOILET PAPER.
5 x 5 x 5 IN. (12.7 x 12.7 x 12.7 CM) PER ROLL.

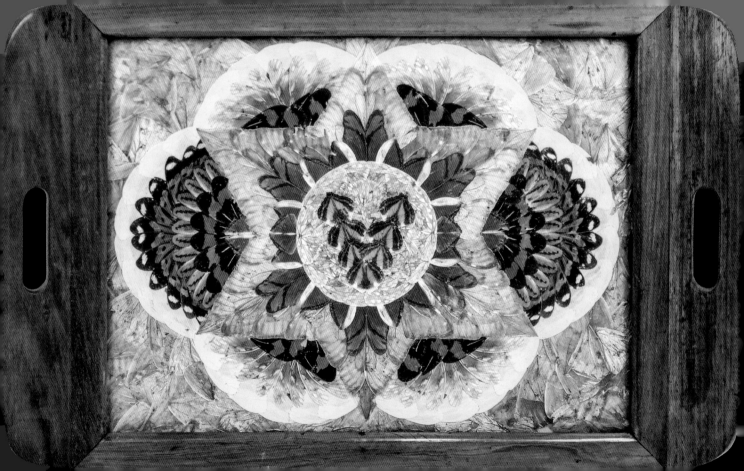

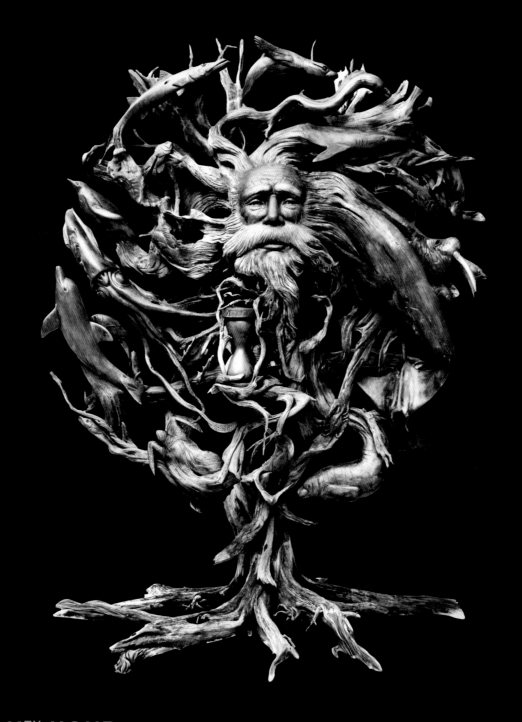

OCEAN'S 11TH HOUR PAUL BALIKER

A CALL TO ACTION

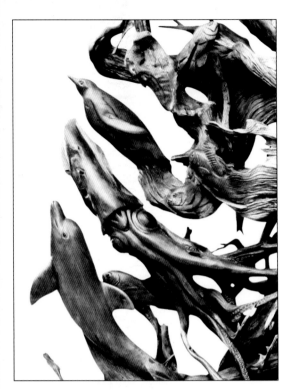

Palm Coast, Florida, artist Paul Baliker specializes in sculptures built out of cedar driftwood, finding his medium along the beaches of Florida's Gulf Coast. Every year, he creates a piece focusing on the relationship between mankind and nature.

> *"We need to take measures right now to quit polluting and overfishing," says Baliker. "We're in the eleventh hour and time is running out."*

Ocean's 11th Hour addresses the dangers of extinction caused by ocean pollution. The 10-ft-tall (3.2-m) piece features over 20 carvings of sea creatures, tangled within the wild mane of Father Time.

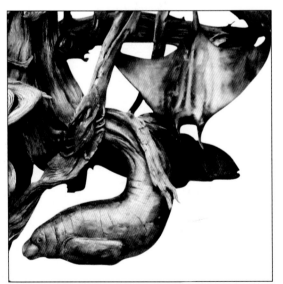

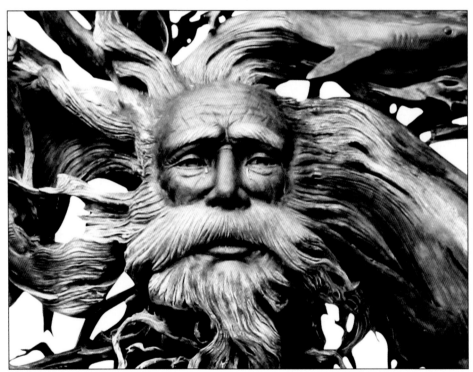

PALM COAST, FLORIDA, UNITED STATES

MADE ENTIRELY FROM PIECES OF CEDAR DRIFTWOOD FOUND ON FLORIDA BEACHES.

8 x 6.6 x 10.4 FT (2.4 x 2 x 3.2 M)

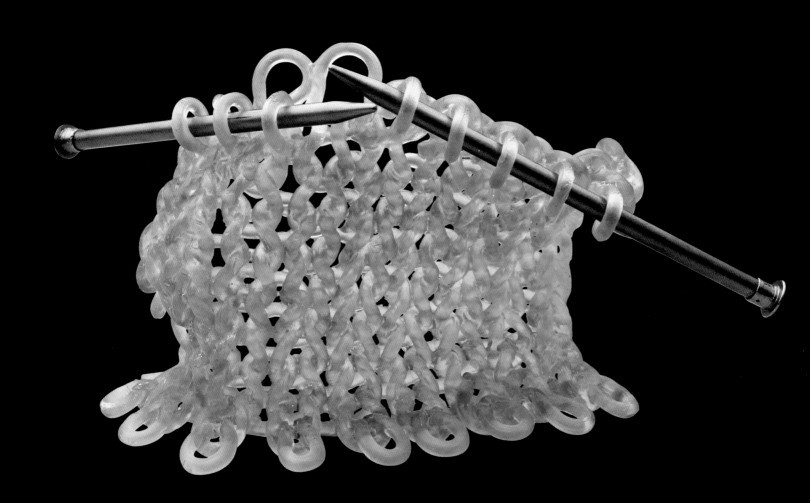

DASH CAROL MILNE

SEATTLE, WASHINGTON, UNITED STATES

THE ARTIST CREATED THE ILLUSION OF FLOATING KNITTING NEEDLES BY FIRST SCULPTING WAX TO CREATE A MOLD, WHICH WAS THEN FILLED WITH GLASS SHARDS THAT MELTED TOGETHER WHEN HEATED IN A KILN. 4.5 x 10 x 5 in (11.4 x 25.4 x 12.7 cm)

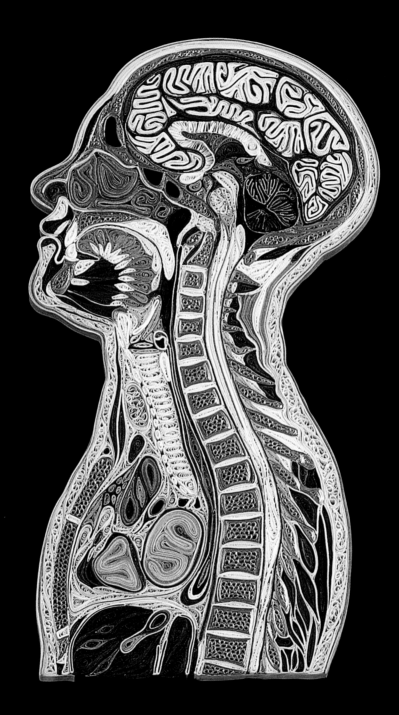

HEAD AND TORSO LISA NILSSON

STOCKBRIDGE, MASSACHUSETTS, UNITED STATES

ANATOMICAL CROSS-SECTION RECREATED WITH MULBERRY PAPER AND THE GILDED EDGES
OF OLD BOOKS USING A TECHNIQUE CALLED QUILLING. 9 x 13 x 1 IN (22.9 x 33 x 2.5 CM)

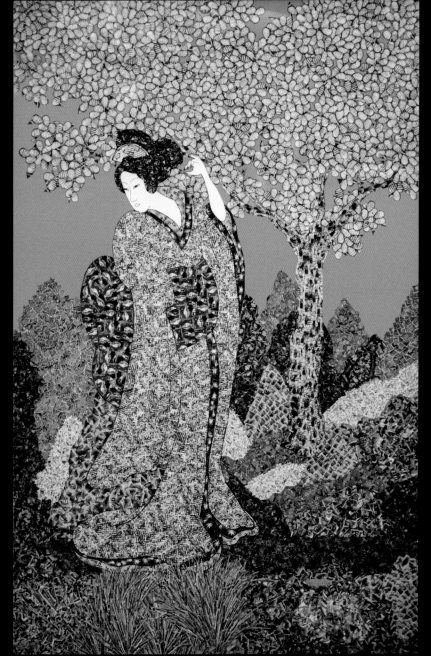

GEISHA WOMAN JAMES BUTMAN

MASSACHUSETTS, UNITED STATES

A GEISHA UNDER A CHERRY TREE CREATED WITH 5,000 POSTAGE STAMPS.
CREATED BY THE ARTIST AS A THERAPY FOR HIS AGORAPHOBIA, OR FEAR OF PUBLIC PLACES.

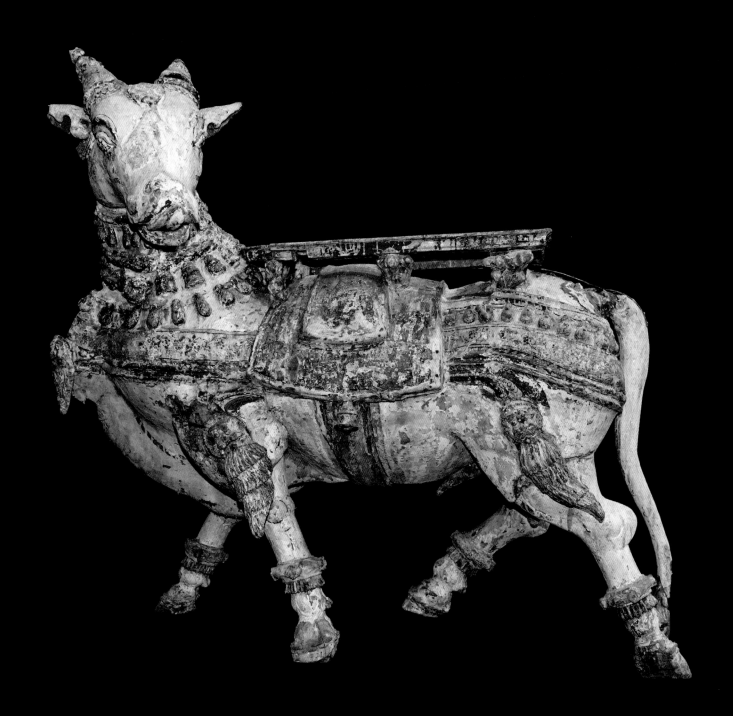

TEMPLE BULL

SRI LANKA

WOOD CARVING OF NANDI, THE GATE-GUARDIAN OF THE HINDU GOD SHIVA,
ONCE OWNED BY ROBERT RIPLEY. 5.25 x 3 x 6 FT (1.6 x 1 x 1.8 M)

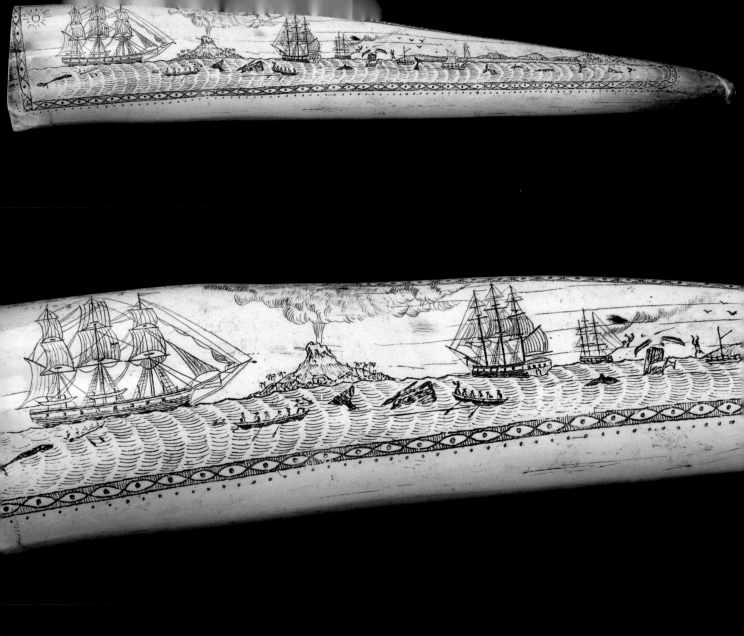

SCRIMSHAW WALRUS TUSK

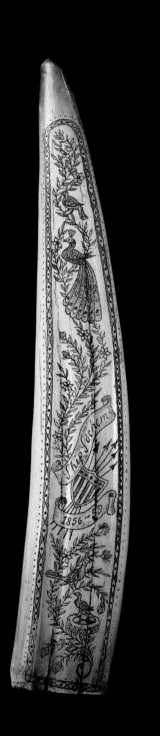

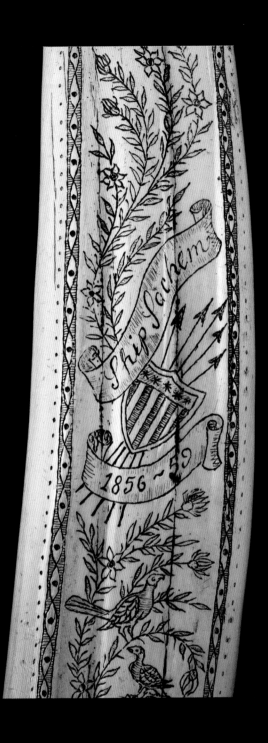

LONG ISLAND, NEW YORK, UNITED STATES
ENGRAVED BY A WHALER ABOARD THE SHIP SACHEM BETWEEN 1856 AND 1859.
13.5 x 2.25 x 1.5 in (34.3 x 5.7 x 3.8 cm)

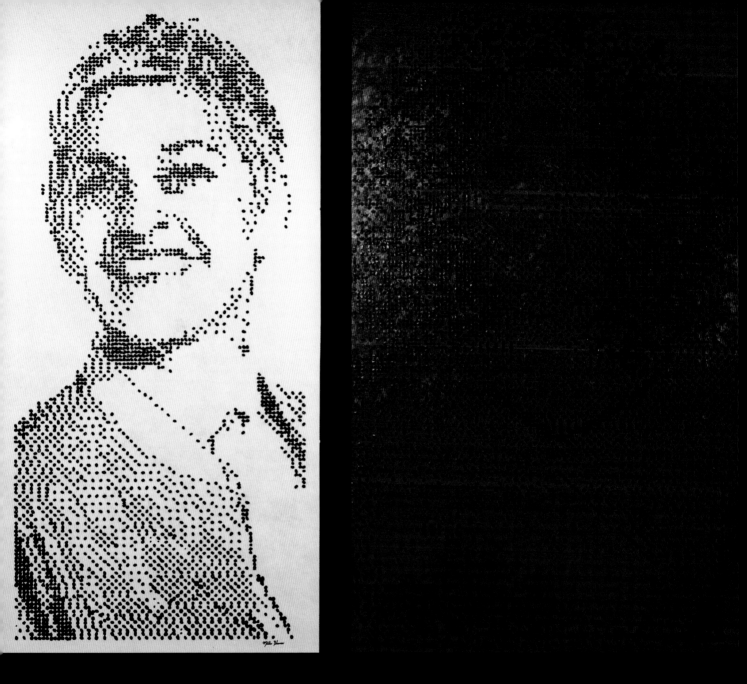

ORLANDO, FLORIDA, UNITED STATES

ELLEN DEGENERES: 3,538 COLOMBIAN COFFEE BEANS. 3.5 x 6.8 FT (1 x 2 M)
OPRAH WINFREY: 9,000 FRENCH ROAST COFFEE BEANS. 4.25 x 6.8 FT (1.3 x 2 M)

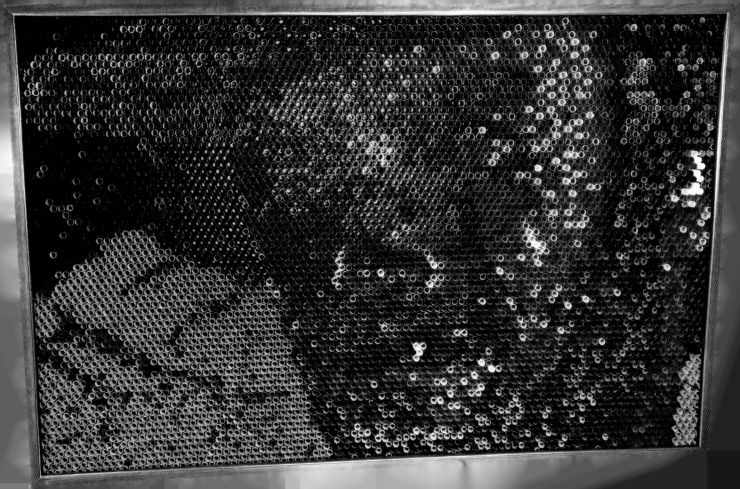

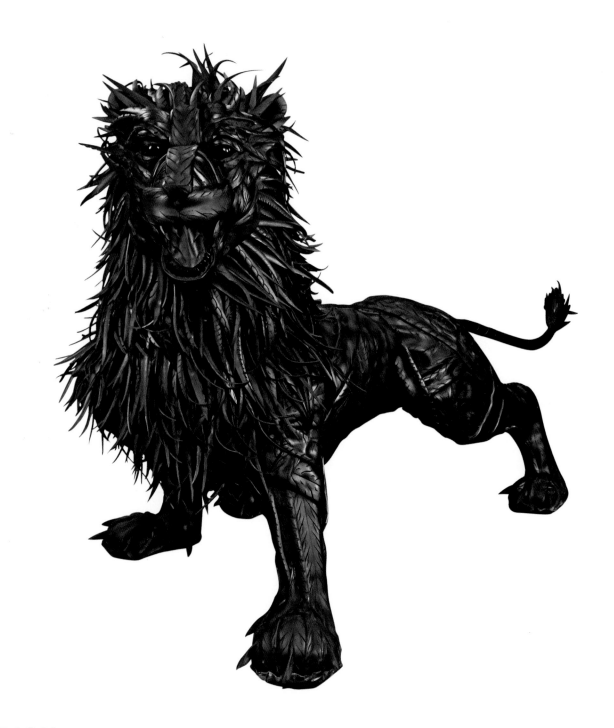

TIRED LION ART FROM STEEL

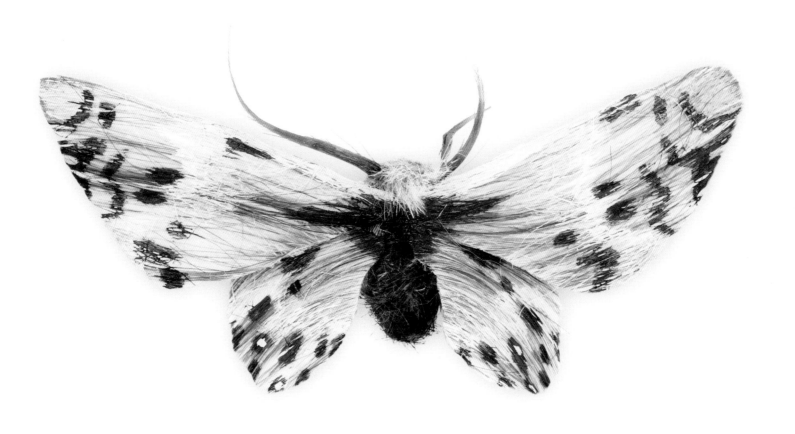

HUMAN HAIR MOTH ADRIENNE ANTONSON

WASHINGTON, UNITED STATES
PART OF A SERIES OF EASTERN MOTHS RECREATED FROM HUMAN HAIR,
WHICH WAS PROVIDED BY THE ARTIST, ALONG WITH HER FRIENDS AND FAMILY.

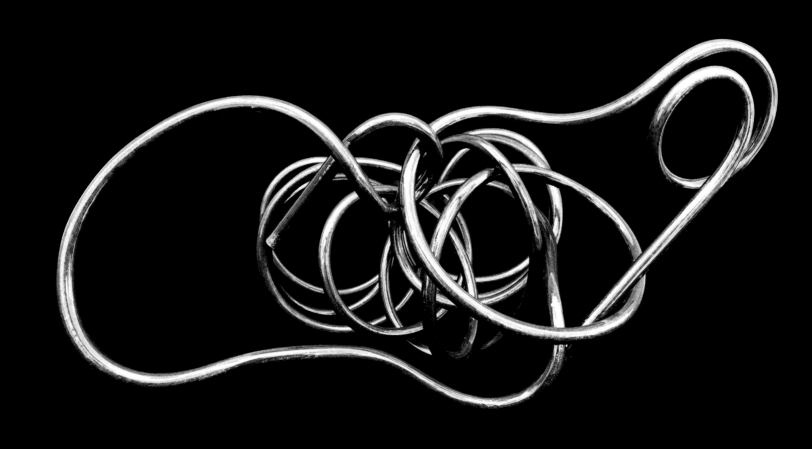

STEEL SCROLLING CHRIS RIDER

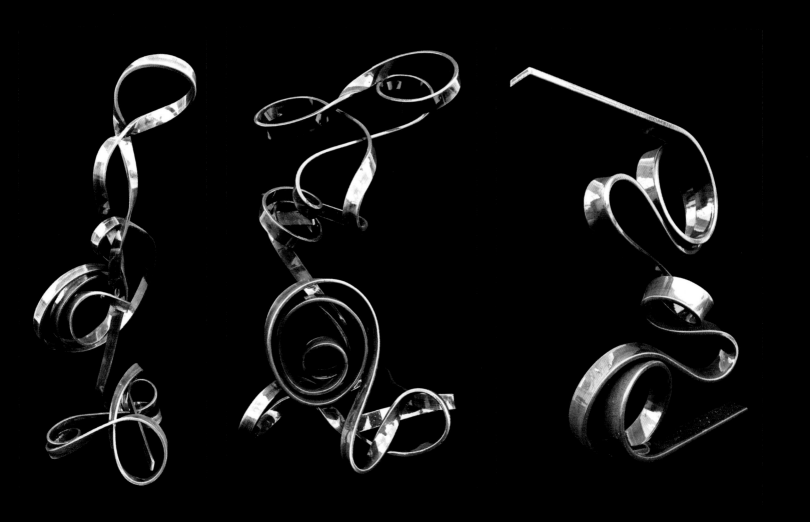

THOMASVILLE, PENNSYLVANIA, UNITED STATES
RODS AND BARS OF COLD STEEL BENT BY HAND USING TRADITIONAL
STRONGMAN TECHNIQUES, WITHOUT THE AID OF HEAT OR TOOLS.

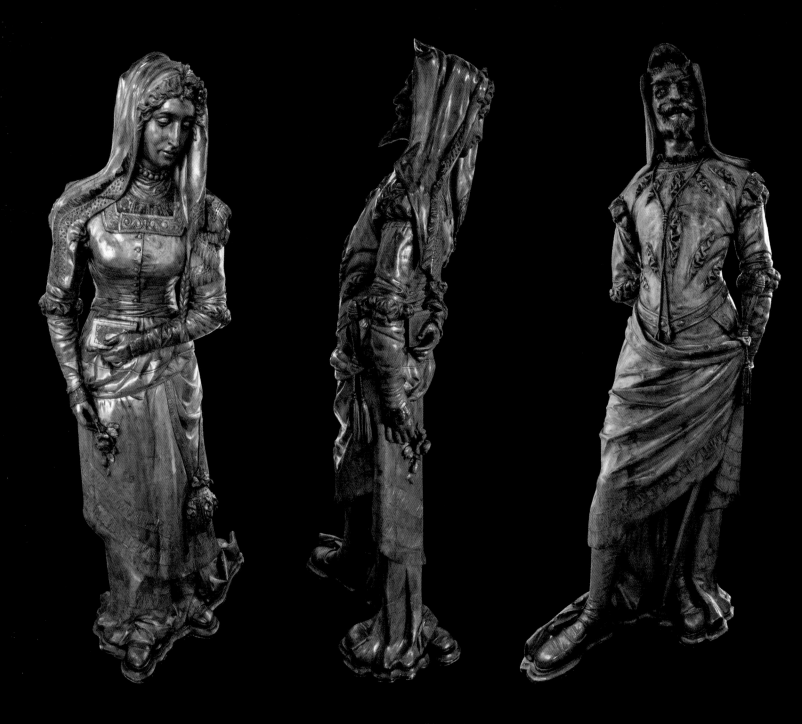

MEPHISTOPHELES AND MARGARETTA

GERMANY

FOUND IN FRANCE IN THE EARLY 19TH CENTURY, THIS DOUBLE-SIDED FRUITWOOD STATUE DEPICTS
CHARACTERS FROM JOHANN WOLFGANG VON GOETHE'S *FAUST*. 5.8 x 1.3 x 2.4 FT (1.8 x 0.4 x 0.7 M)

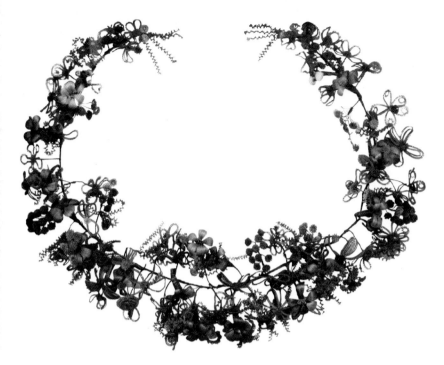

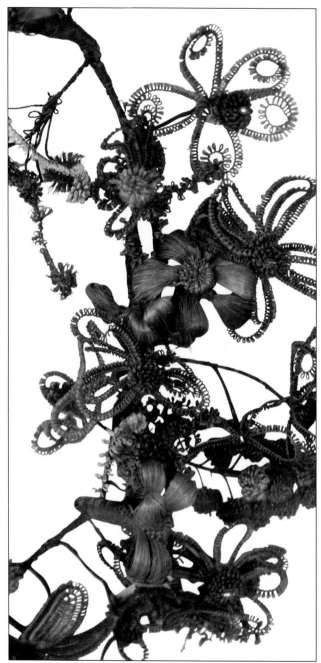

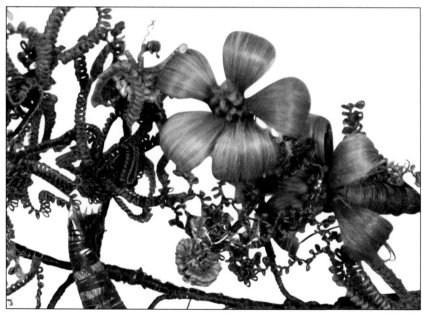

FUNERAL HAIR WREATH CALVIN BRYDGES

SOUTHWESTERN ONTARIO, CANADA

POPULAR DURING THE VICTORIAN ERA, FAMILY WREATHS WERE CREATED WITH
LOCKS OF HAIR FROM THE DECEASED AND WOULD BE ADDED TO OVER TIME.

FLY ON THE WALL STEVEN KUTCHER

THE ARTIST DIPS THE LEGS OF LIVE INSECTS INTO NONTOXIC PAINT BEFORE GUIDING THEM ALONG A WET CANVAS
MOUNTED ON A LAZY SUSAN. THIS PIECE WAS CREATED BY A HISSING COCKROACH. 1.5 x 2 FT (0.5 x 0.6 M)

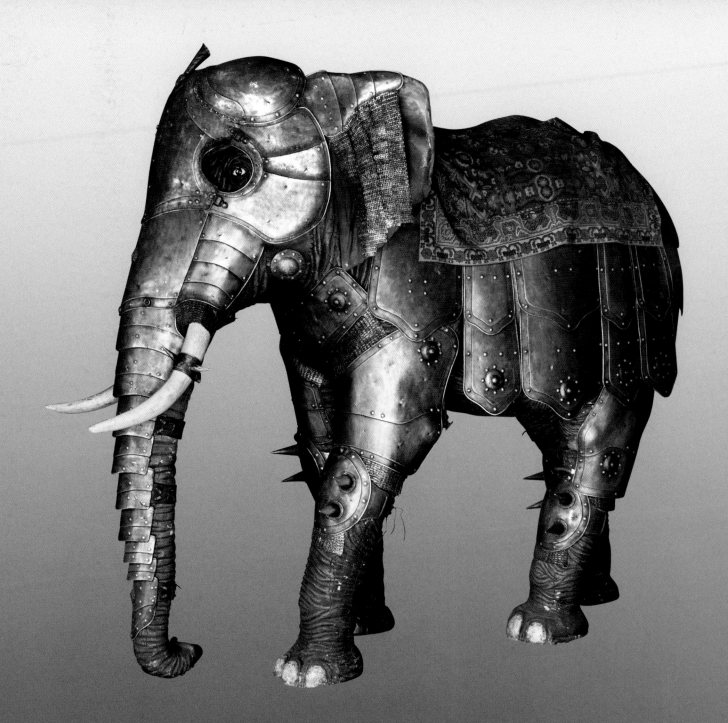

ELEPHANT ARMOR

INDIA

FOUND IN A BRITISH ARMORY, THIS 18TH-CENTURY INDO-PERSIAN ARMOR INCLUDES CHAIN MAIL EAR PROTECTORS.
12 x 4 x 8 FT (3.7 x 1.2 x 2.4 M)

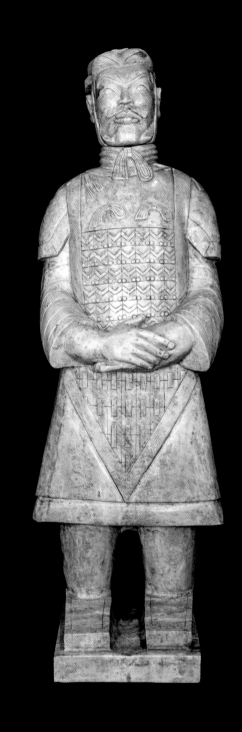

JADE SOLDIER

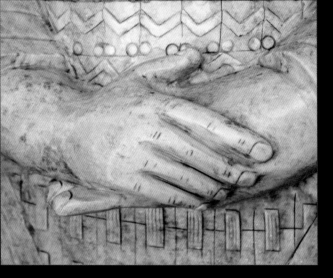
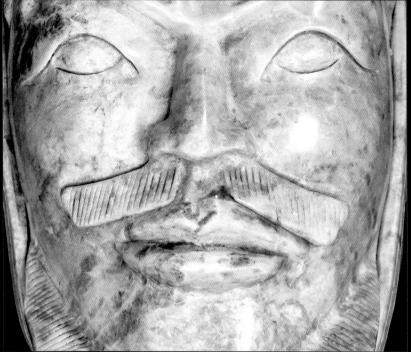
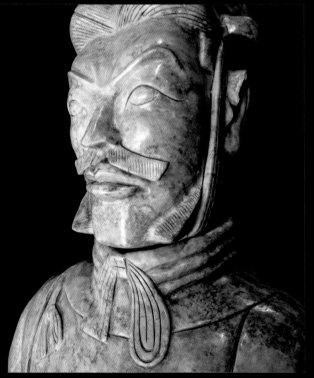
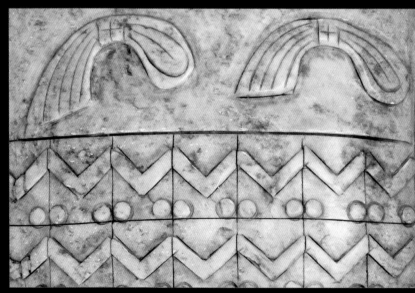

A REPLICA OF A GENERAL FROM THE TERRA-COTTA ARMY DISCOVERED OUTSIDE OF XI'AN, CHINA, IN 1974, MADE OF TWO SOLID PIECES OF JADE, WEIGHING A TOTAL OF 1,200 LB (545 KG), 5.6 x 1.8 x 1.8 FT (1.7 x 0.6 x 0.6 M)

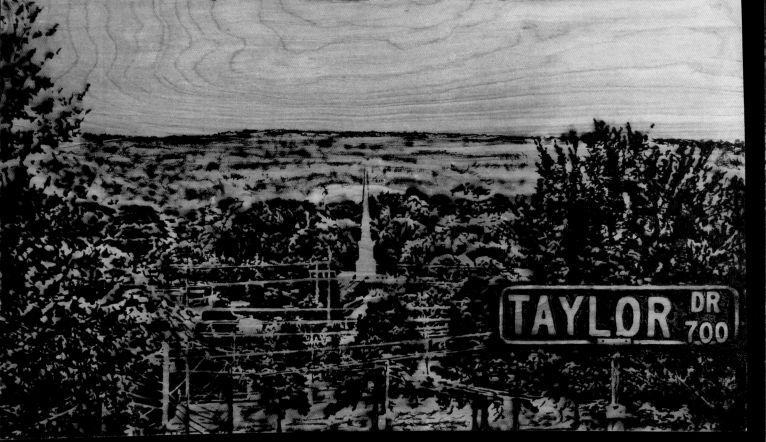

PAINTING WITH LIGHT

Michael Papadakis from Colorado was trying to find a way to travel light while still being able to create art when he had an epiphany—the Sun's power can be harnessed from anywhere on Earth. By reflecting and refracting its light to burn images onto a wooden surface, he is able to make art anywhere he goes. Humbled by the possibilities, he started Sunscribes with the mission:

> "To teach every child and adult the privilege and responsibility of holding the power of the Sun in their hands. My hope is that someday, this constructive approach will have lasting impacts on future generations."

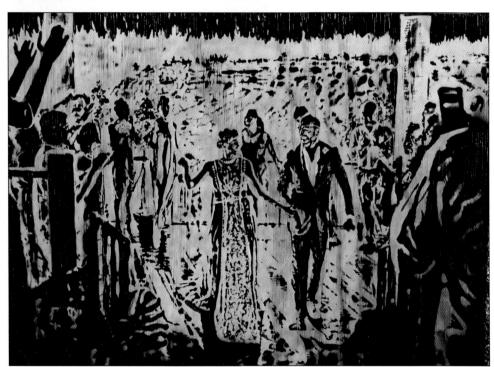

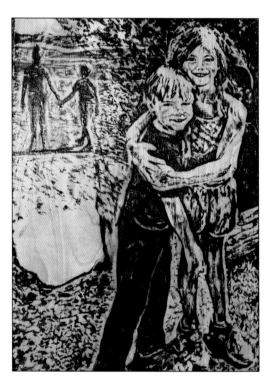

RANCHO SANTA MARGARITA, CALIFORNIA, UNITED STATES

BY HARNESSING THE POWER OF THE SUN WITH GLASS AND MIRRORS, THE ARTIST BURNS IMAGES ONTO WOODEN CANVASES, A TECHNIQUE KNOWN AS *HELIOGRAPHY*.

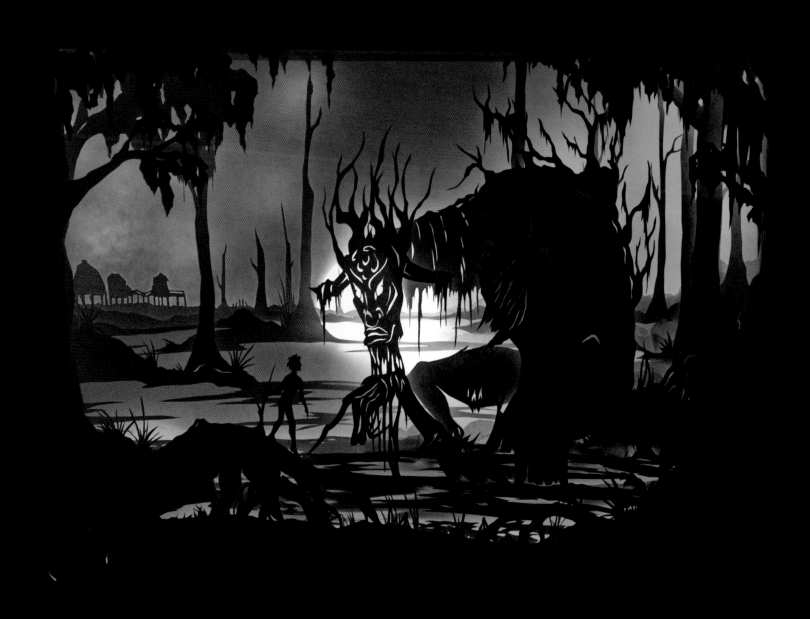

THE OLD WAYS BRITTANY COX

SEATTLE, WASHINGTON, UNITED STATES
FOURTEEN LAYERS OF HANDCUT PAPER ARRANGED IN A FRAME AND LIT
FROM BEHIND, CREATING A THREE-DIMENSIONAL SCENE. 24 x 18 IN (61 x 45.7 CM)

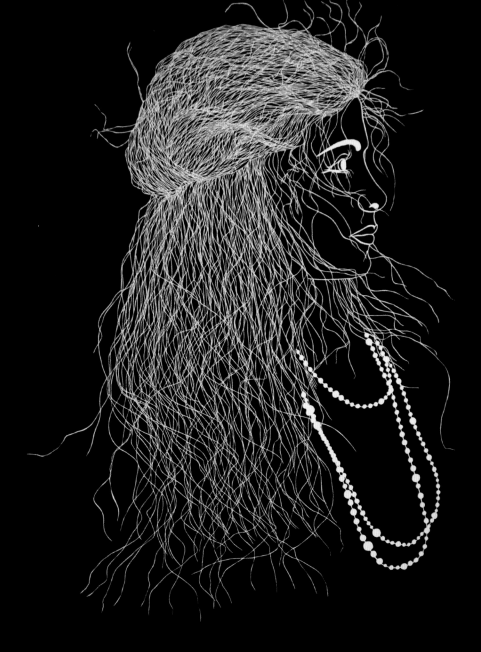

GIRL WITH THE PEARL NECKLACE MAUDE WHITE

HUDSON, NEW YORK, UNITED STATES

FINELY DETAILED PROFILE OF A WOMAN WEARING A NECKLACE
CUT FROM A SINGLE SHEET OF PAPER. 25 x 21 IN (63.5 x 53.3 CM)

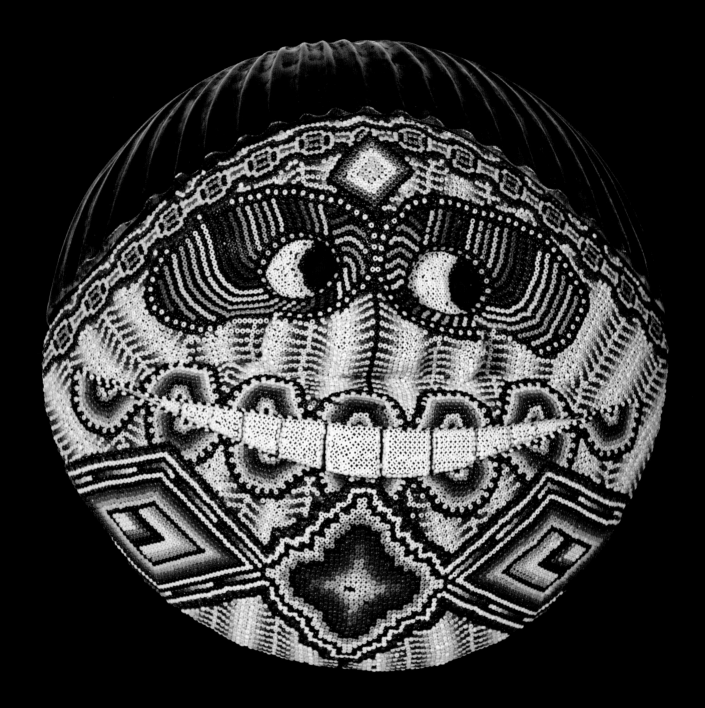

YAGÉ MASK

COLOMBIA

BEADED MASK DEPICTING THE FACE OF SOMEONE EXPERIENCING THE HALLUCINOGENIC EFFECTS OF YAGÉ FRUIT.

12 x 12 x 4 IN (30 x 30 x 10 CM)

THE LAST MEAL MAX ZORN

AMSTERDAM, NETHERLANDS
CREATED BY LAYERING INTRICATELY CUT PIECES OF PACKING TAPE ONTO BACKLIT GLASS
3 x 2 FT (1 x 0.6 M)

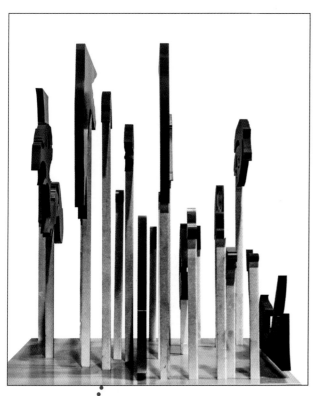

SIDE VIEW

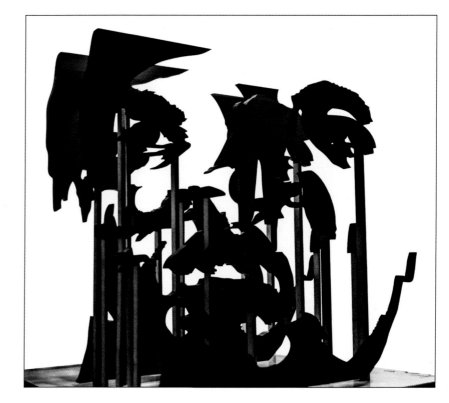

MUHAMMAD ALI MICHAEL KALISH

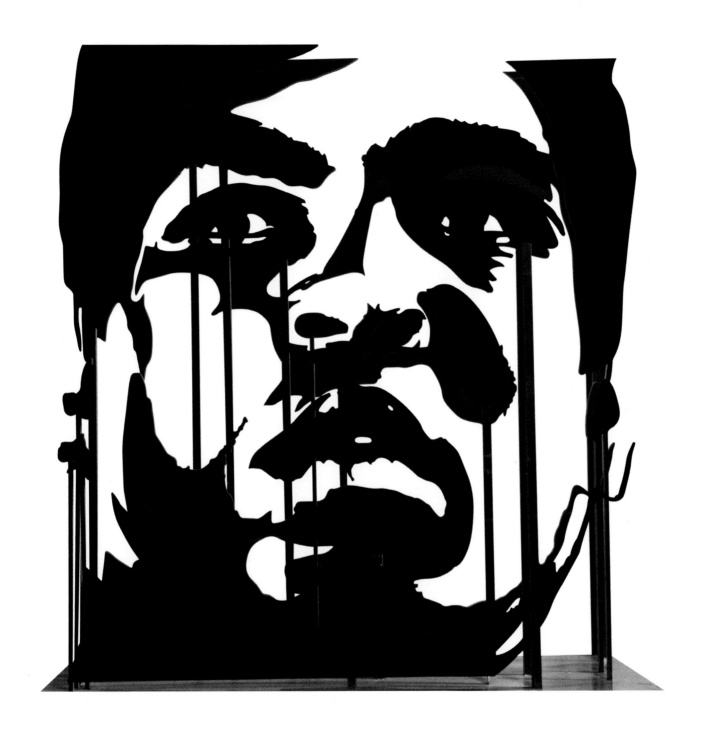

LOS ANGELES, CALIFORNIA, UNITED STATES
LAYERS OF STEEL THAT, WHEN PROPERLY ALIGNED, FORM AN IMAGE OF MUHAMMAD ALI.
1.5 x 1.5 x 1.5 FT (0.5 x 0.5 x 0.5 M)

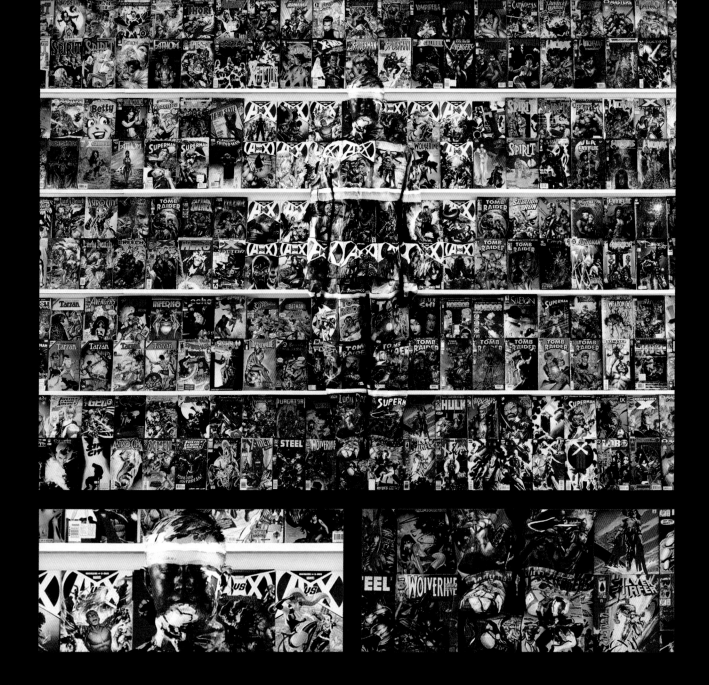

THE INVISIBLE MAN LIU BOLIN

ONE OF OVER A HUNDRED SCENES THAT THE ARTIST HAS BLENDED HIMSELF INTO
WITH THE HELP OF A TEAM OF PAINTERS AND A PERFECTLY ANGLED CAMERA.

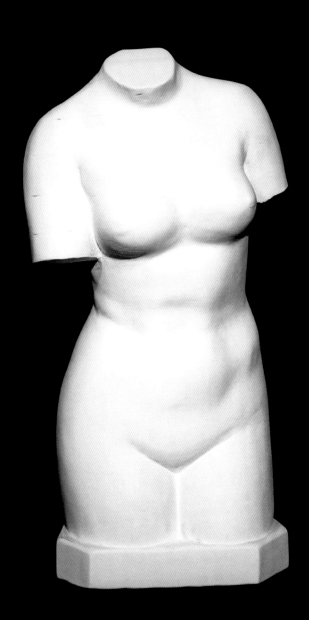

TORSO OF A YOUNG WOMAN LI HONGBO

BEIJING, CHINA

EXPANDABLE PAPER SCULPTURE CREATED WITH THE SAME HONEYCOMB GLUING
TECHNIQUES USED TO MAKE PAPER GOURDS IN CHINA. 22.8 x 12.6 x 9.8 IN (58 x 32 x 25 CM)

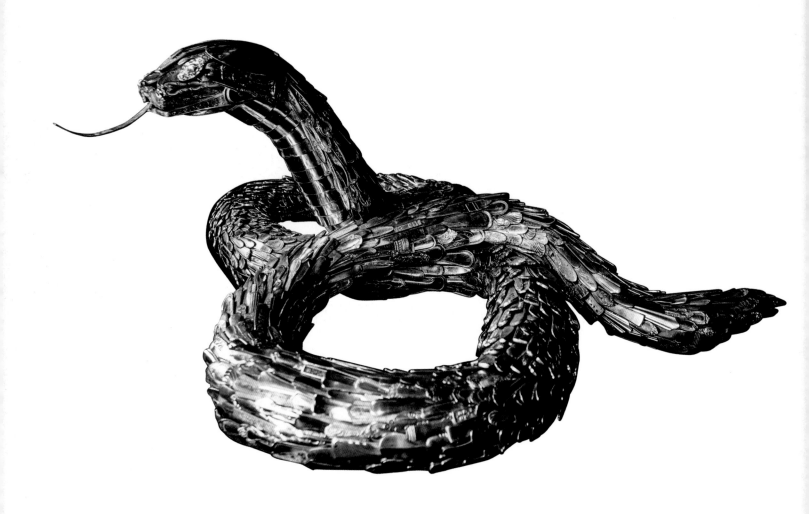

SPOON SNAKE JUSTIN LA DOUX

ALMA, MICHIGAN, UNITED STATES
CREATED FROM HUNDREDS OF RECYCLED SPOONS.
14 x 34 x 34 IN (35.6 x 86.4 x 86.4 CM)

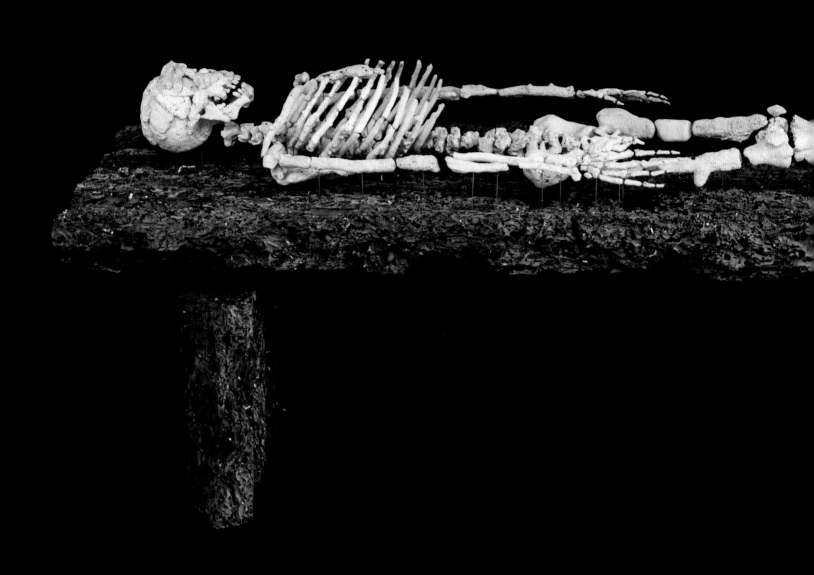

CORAL SKELETON GREGORY HALILI

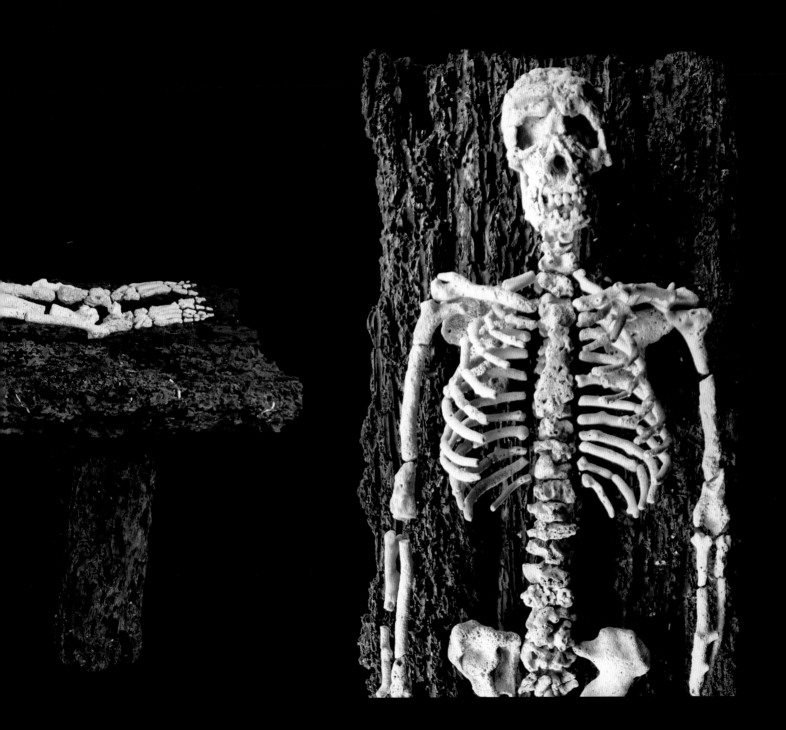

SILANG, CAVITE, PHILIPPINES

LIFE-SIZE SKELETON CREATED WITH PIECES OF DEAD CORAL FOUND ALONG
THE BEACHES OF CALATAGAN, ANILAO, AND BOLINAO IN THE PHILIPPINES.

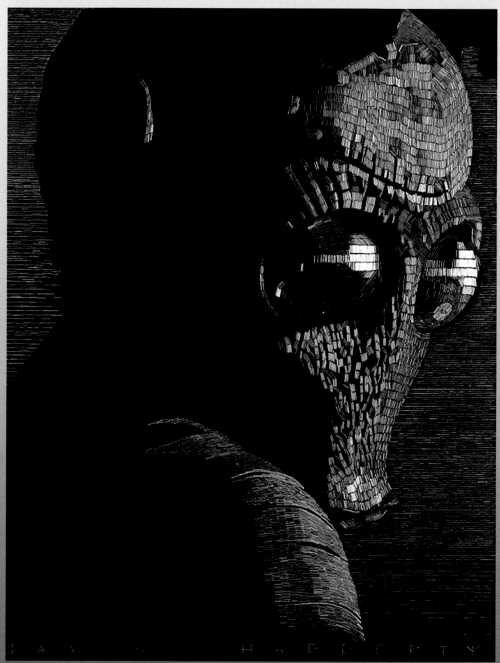

LIMBO JAMES HAGGERTY

BROOKLYN, NEW YORK, UNITED STATES

A PORTRAIT OF *STAR WARS* CHARACTER GREEDO MADE FROM 21,458 COLORED STAPLES ON A BLACK BOARD.
40 x 32 IN (101.6 x 82.3 CM)

ARARAUNA KIM "KIMJOYMM" MAGBANUA

VALLADOLID, PHILIPPINES

A FULL-TIME NURSE, THIS ARTIST USES SYRINGES TO PAINT
SUBJECTS LIKE BIRDS, FISH, AND PEOPLE.

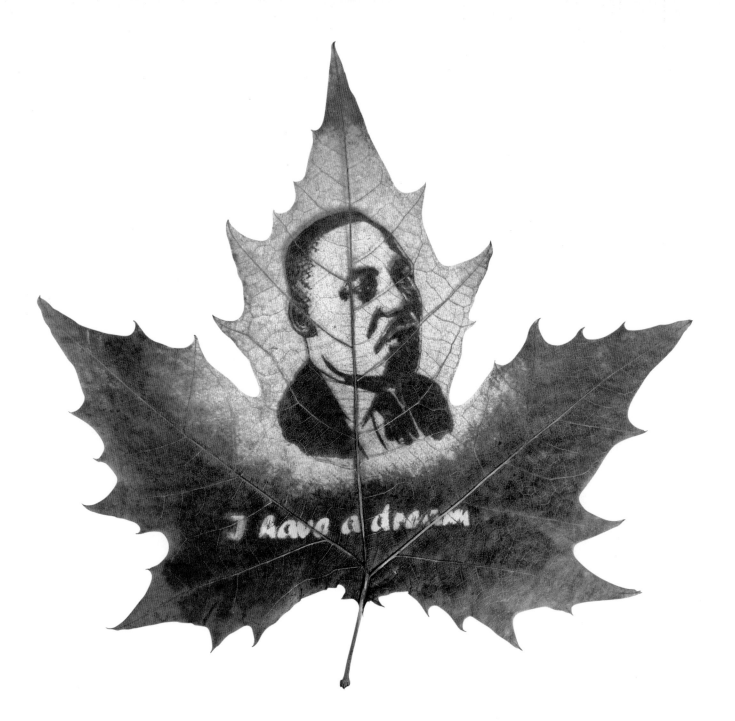

LEAF CARVING

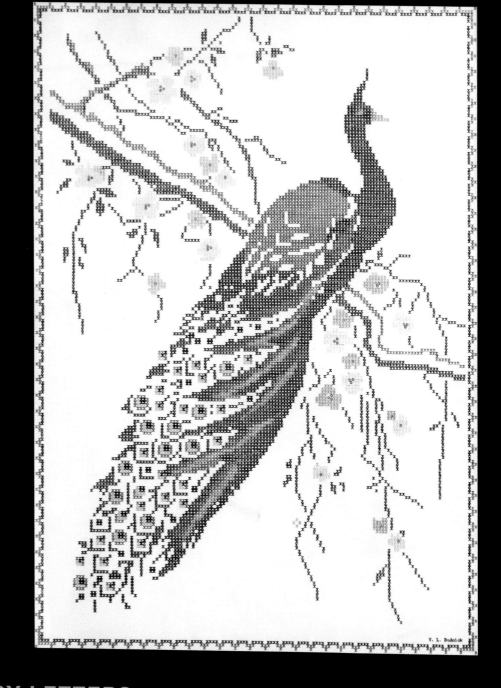

PAINTING BY LETTERS VIOLA L. BUDNICK

MILWAUKEE, WISCONSIN, UN

PEACOCK ON A BRANCH TYPED WITH A TYPEWRITER USING BLUE, GREEN, PURPLE, AND
THE ARTIST USED ONLY THE LETTER X, GIVING THE PIECE A CROSS-STICHED APPEARNCE. 2

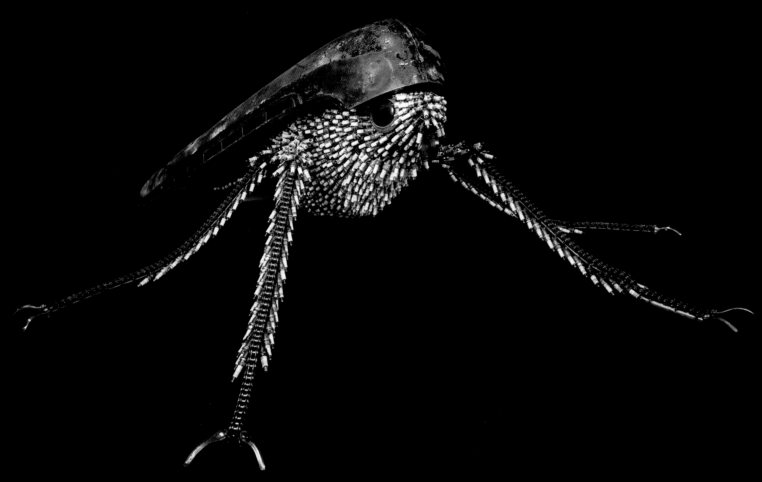

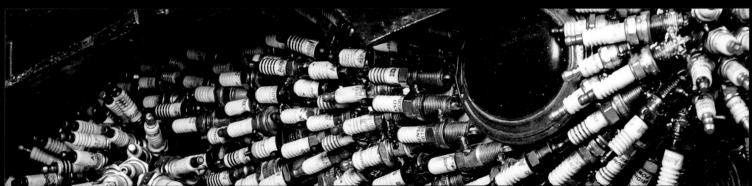

PART ART BENJAMIN NEWMAN

ROSEVILLE, CALIFORNIA, UNITED STATES

MOTH MADE FROM MORE THAN 1,000 VINTAGE SPARK PLUGS AND THE HOOD OF A 1940S CAR.

2.3 x 7.3 x 8.4 FT (0.7 x 2.2 x 2.6 M)

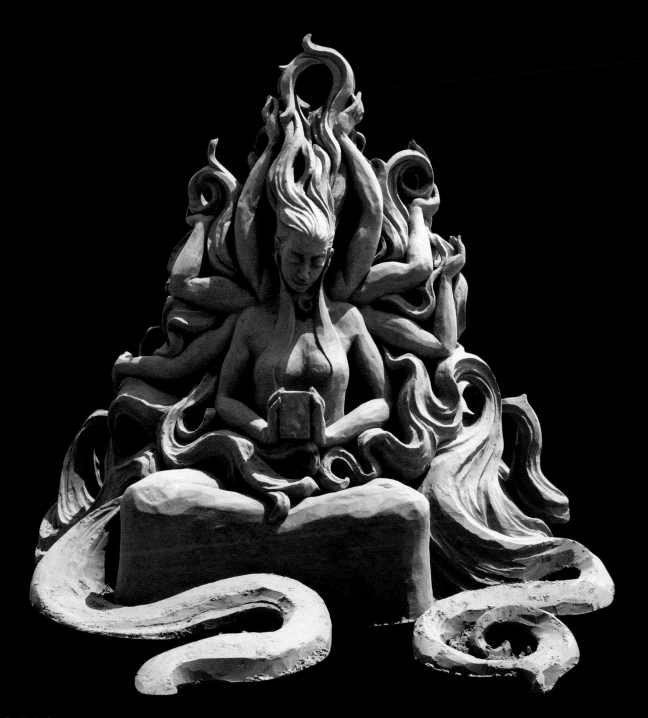

EUPHORIA CARL JARA

CLEVELAND HEIGHTS, OHIO, UNITED STATES
HAND SCULPTED SAND, PACKED FROM THE GROUND UP IN LAYERS NO MORE THAN 2 IN (5 CM)
THICK AT A TIME. ONLY WATER IS USED TO HOLD THE SCULPTURE TOGETHER.

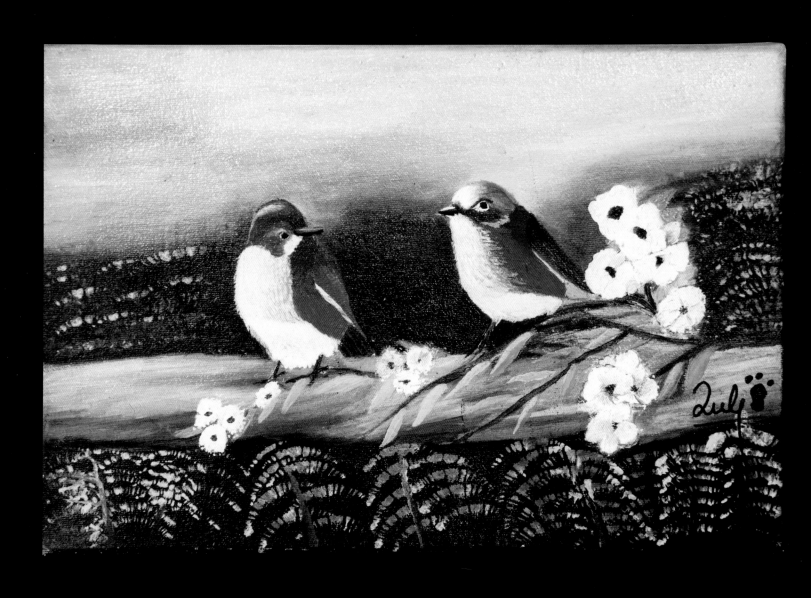

PAINTINGS BY ZULY SANGUINO

NO LIMITS

Zuly Sanguino of Bogotá, Colombia, was born with tetra-amelia syndrome, a rare genetic disorder that left her with underdeveloped arms and legs. At the age of 18, she began studying art and now creates paintings like the ones shown here. Zuly refers to herself as a "no arms, no legs, no limits artist."

> *"I want to show people you can do anything if you put your mind to it."*

Now in her late-twenties, she is a successful motivational speaker, inspiring bullied children and kids with disabilities at schools as well as giving talks at businesses and prisons.

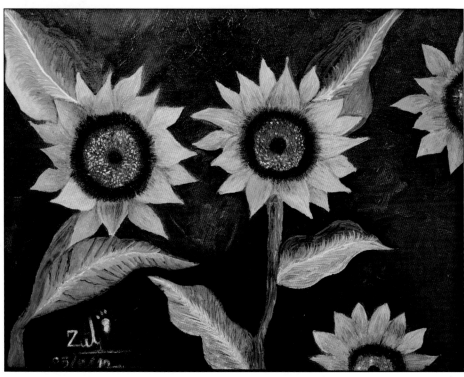

BOGOTÁ, COLOMBIA

THE ARTIST, BORN WITH UNDERDEVELOPED LIMBS, PAINTED THESE BY HOLDING A PAINTBRUSH BETWEEN HER CHIN AND SHOULDER OR IN HER MOUTH.

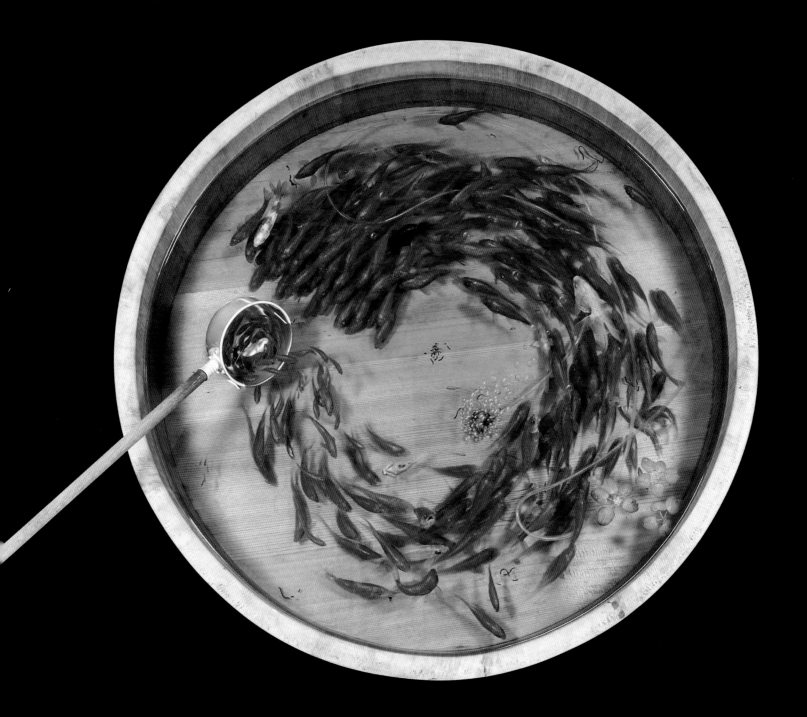

MUSES RIUSUKE FUKAHORI

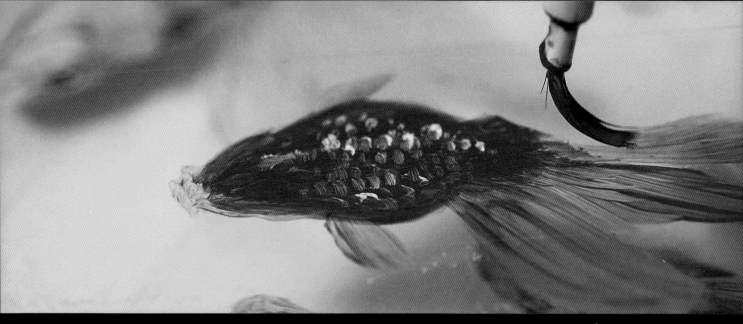

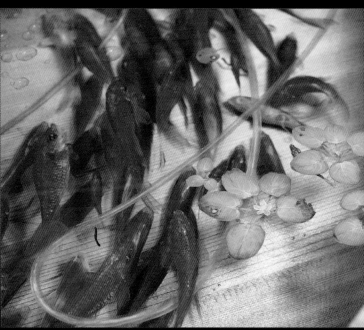

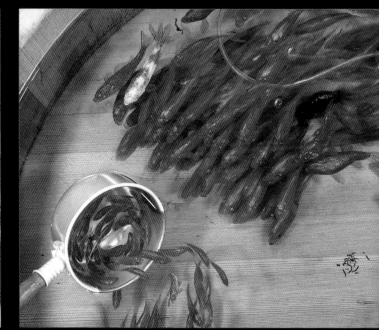

LAYERS OF RESIN ARE POURED AND PAINTED WITH ACRYLICS TO CREATE A REALISTIC
AND 3-D REPRESENTATION OF GOLDFISH FROZEN IN TIME. 23.6 x 5.9 IN (60 x 15 CM

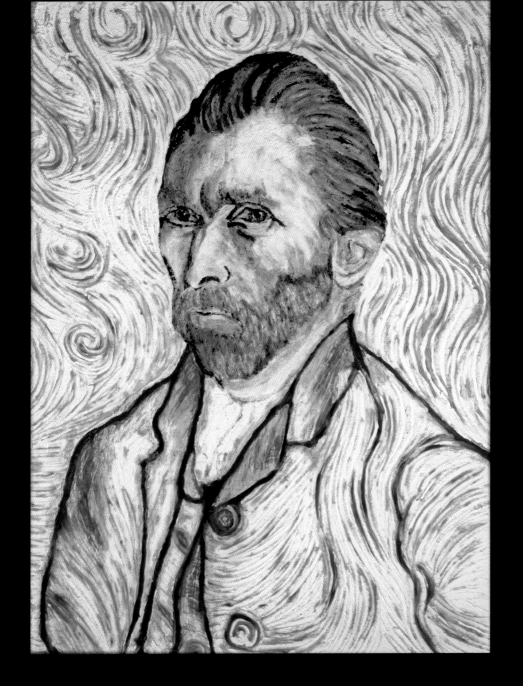

RESH NEW LOOK ROBERTO BERNARD DE LEON

ORLANDO, FLORIDA, UNITED STATES

VINCENT VAN GOGH'S 1889 *SELF-PORTRAIT* RECREATED WITH DIFFERENT
COLORED TOOTHPASTES FROM AROUND THE WORLD. 4.3 x 3.3 FT (1.3 x 1 M)

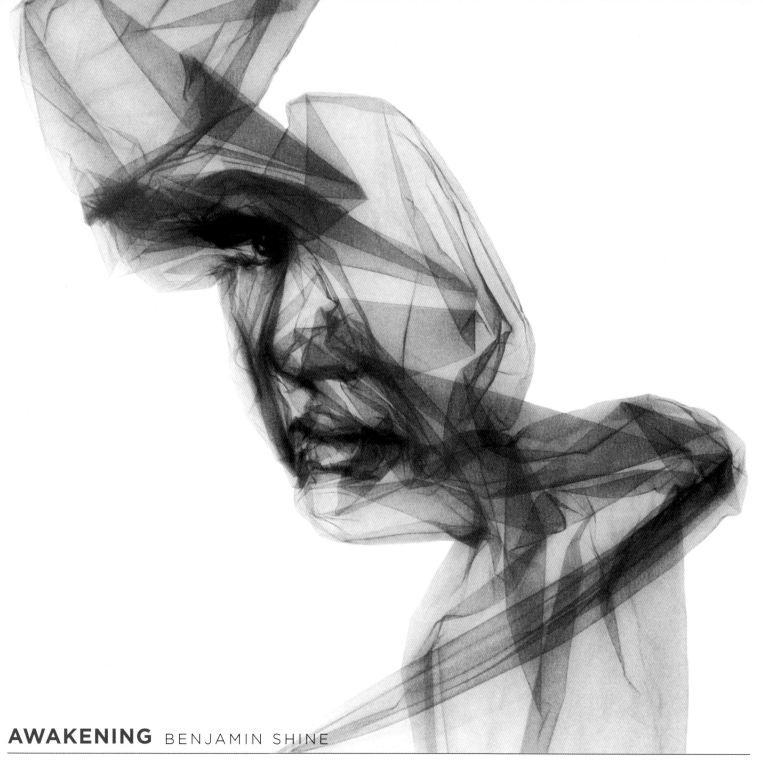

AWAKENING BENJAMIN SHINE

LONDON, ENGLAND
USING A HOUSEHOLD IRON TO PRESS FOLDS INTO A SINGLE PIECE OF TULLE, THE ARTIST
TRANSFORMS THE FABRIC INTO A SMOKE-LIKE PORTRAIT ON CANVAS. 4.8 x 4.8 FT (1.5 x 1.5 M)

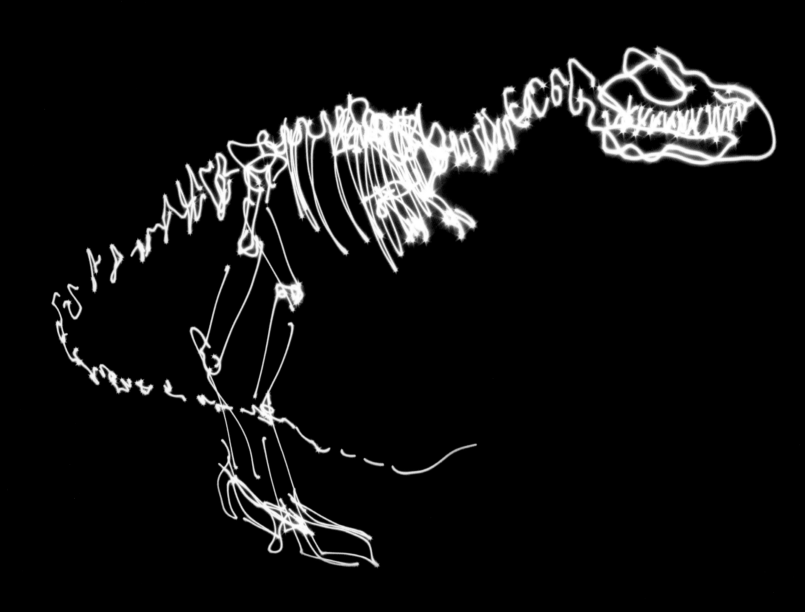

T-REX, GET OFF MY COFFEE TABLE DARREN PEARSON

SOUTHERN CALIFORNIA, UNITED STATES

LIGHT PAINTING DRAWN, AS THE TITLE SUGGESTS, IN THE AIR ABOVE THE ARTIST'S COFFEE TABLE
WITH A MARKER-SHAPED LED LIGHT AND CAPTURED WITH LONG-EXPOSURE PHOTOGRAPHY.

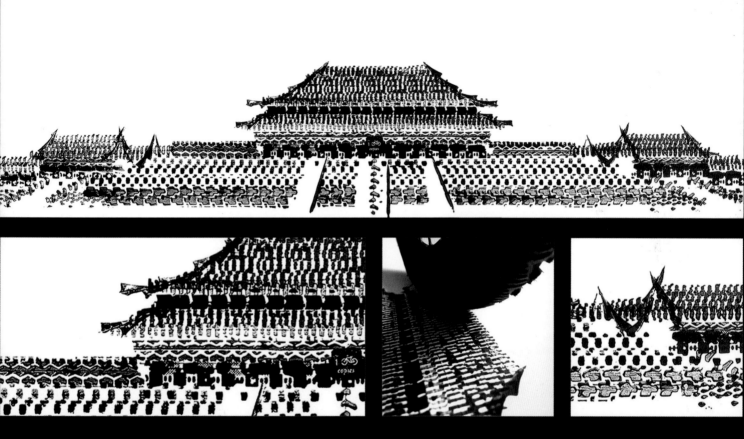

THE UNFORBIDDEN CYCLIST THOMAS YANG

SINGAPORE

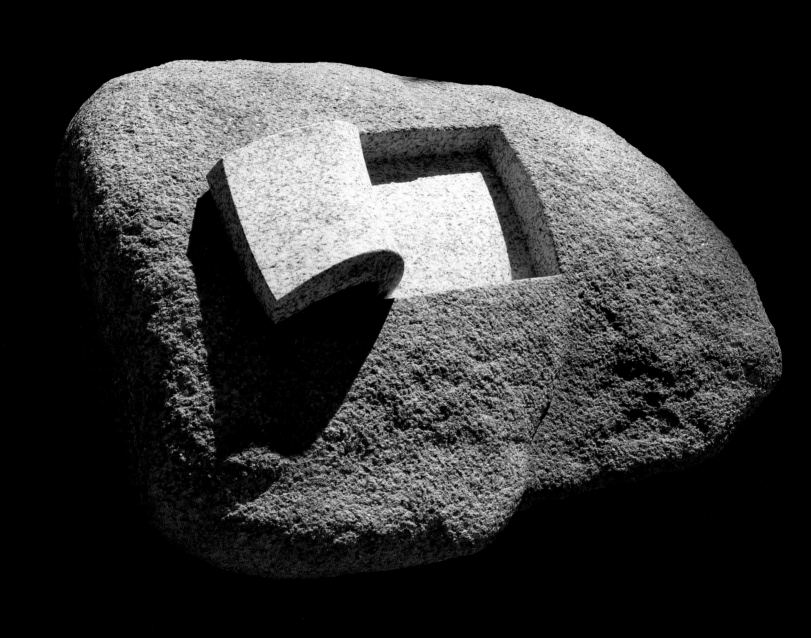

STONE CARVING JOSÉ MANUEL CASTRO LÓPEZ

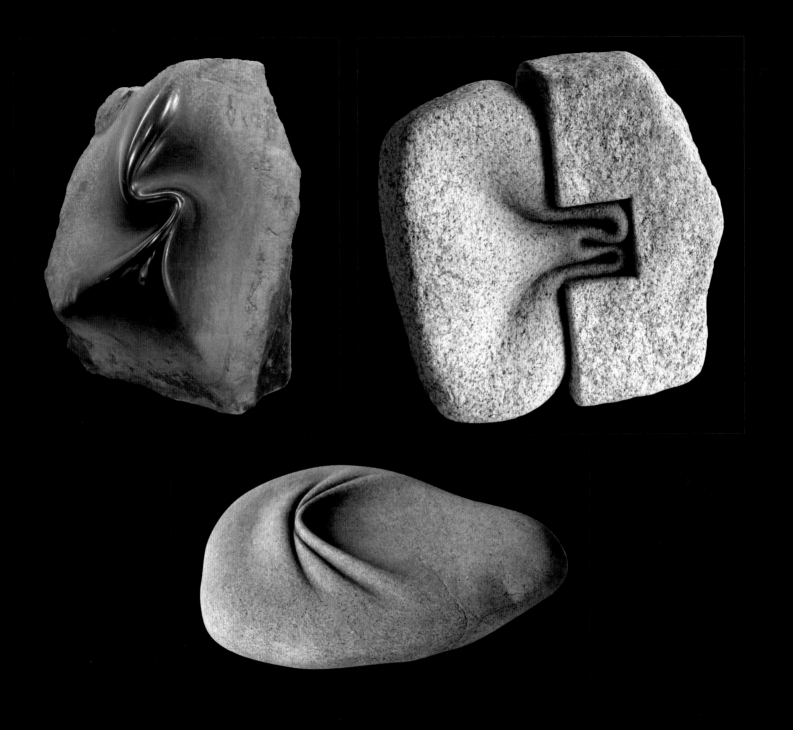

A CORUÑA, SPAIN

STONES LIKE QUARTZ AND GRANITE CARVED WITH SUCH DETAIL THAT THEY APPEAR TO BE MADE OF MUCH SOFTER AND MORE MALLEABLE MATERIALS. SIZES RANGE FROM HANDHELD ROCKS TO MASSIVE BOULDERS.

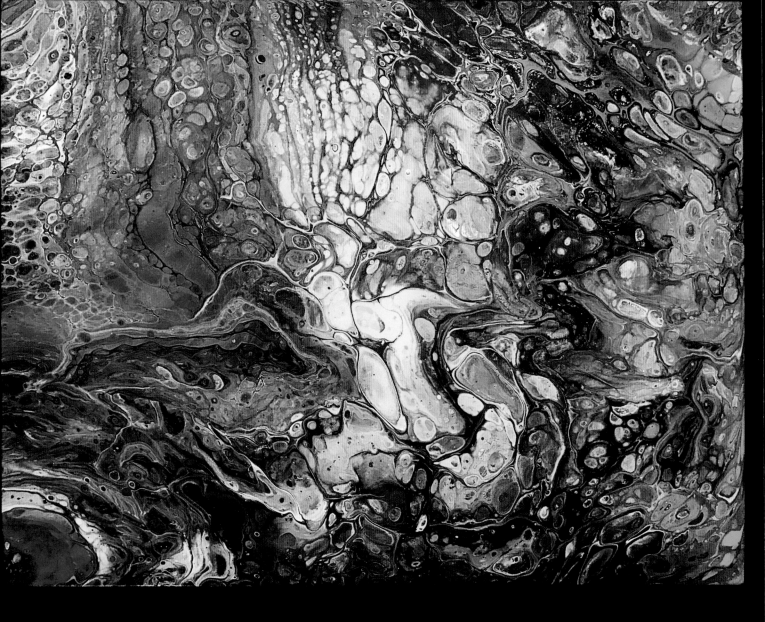

ONE HUNDRED COLORS NICKY JAMES BURCH & LAUREN LAREE

PROVIDENCE VILLAGE, TEXAS, UNITED STATES

A TALL CUP WAS FILLED WITH 100 DIFFERENT COLORS OF ACRYLIC PAINT BEFORE BEING
FLIPPED ONTO MASONITE AND SLOWLY LIFTED TO RELEASE THE PAINT. 16 x 20 IN (40.6 x 50.8 CM)

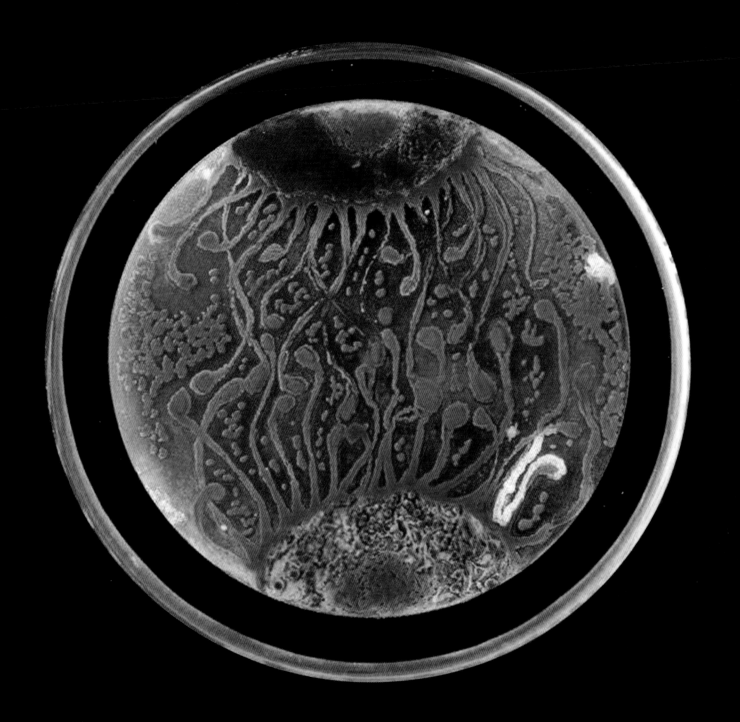

CELL TO CELL MEHMET BERKMEN & MARIA PENIL

IPSWICH, MASSACHUSETTS, UNITED STATES
A PETRI DISH FILLED WITH MICROBES GROWN ON AGAR IN THE
SHAPE OF CELLS WITH TENDRILS REACHING OUT FOR EACH OTHER.

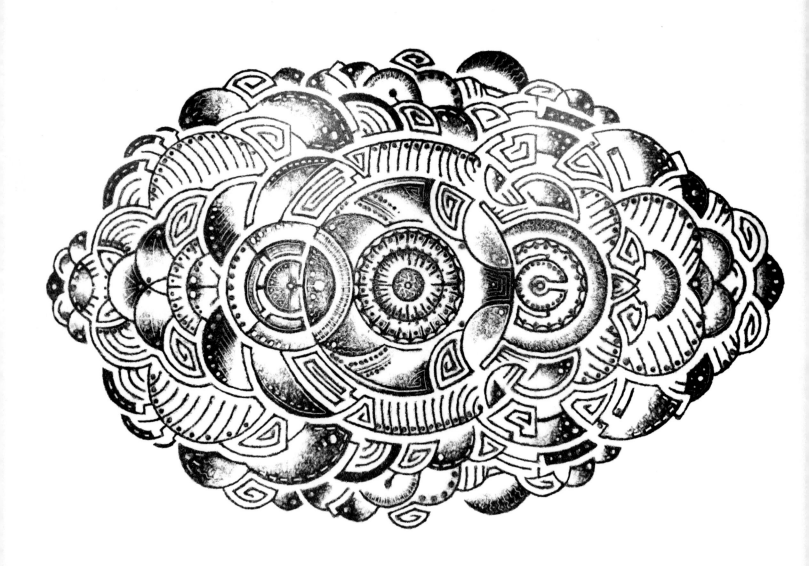

GUNPOWDER MANDALA DINO TOMIC

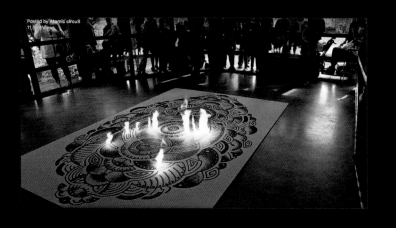
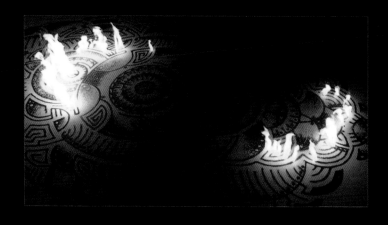
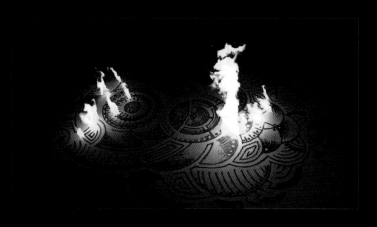
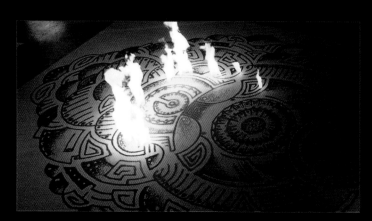
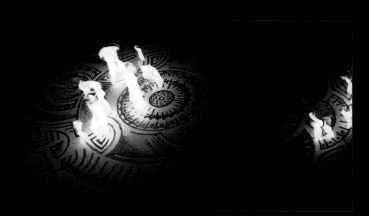
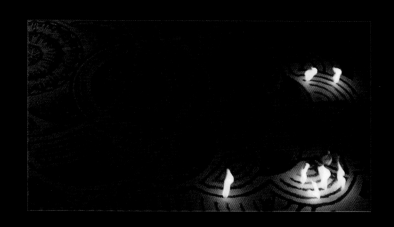

NOTODDEN, NORWAY

THE ARTIST USED A SPOON TO ARRANGE GUNPOWDER INTO A PATTERN BEFORE LIGHTING ONE END.
THE FLAMES BLAZED FOR SIX MINUTES, FOLLOWING THE LINES WHILE BURNING THE PATTERN ONTO THE BOARD.

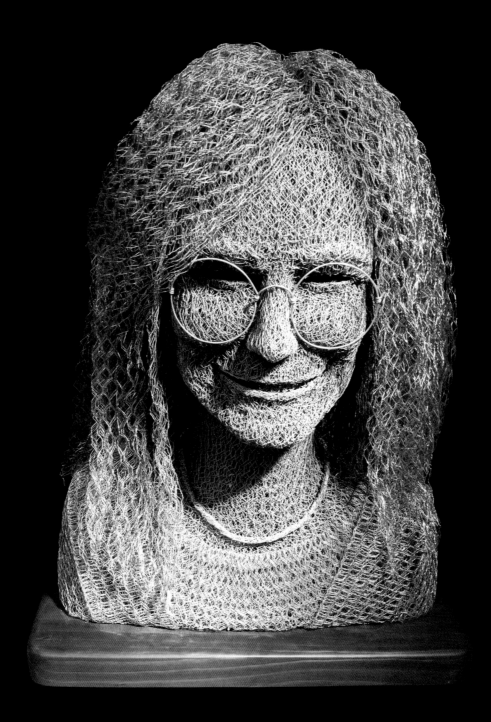

WIRED FOR SOUND IVAN LOVATT

GOLD COAST HINTERLAND, AUSTRALIA
LARGER THAN LIFE BUST OF JANIS JOPLIN MADE ENTIRELY FROM GALVANIZED CHICKEN WIRE.
24.5 x 19.5 x 13.5 IN (62.2 x 49.5 x 34.3 CM)

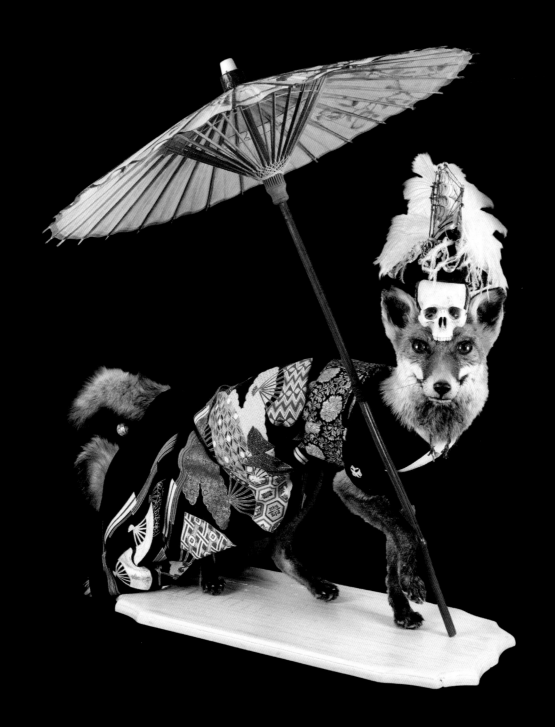

KITSUNE LUCIA MOCNAY

MELBOURNE, AUSTRALIA
TAXIDERMY INSPIRED BY KITSUNE, THE NINE-TAILED FOX OF JAPANESE FOLKLORE.
PART OF THE ARTIST'S *CONJURED CREATIONS* COLLECTION.

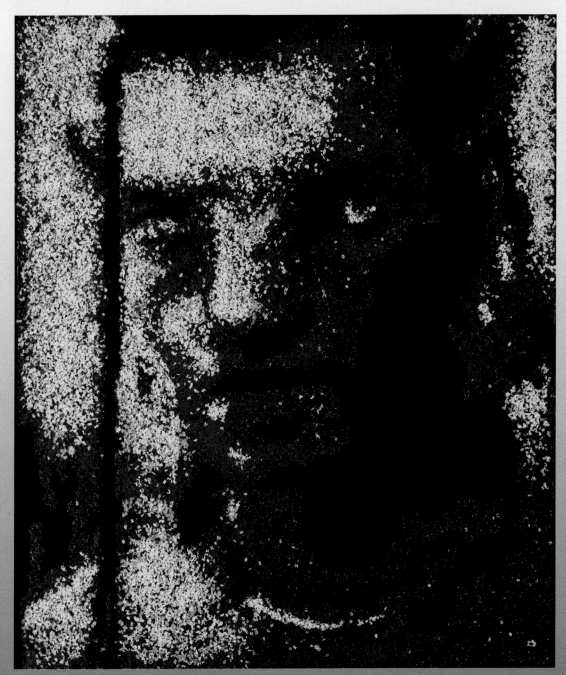

ALPHABET AVATAR MATEO BLANCO

ORLANDO, FLORIDA, UNITED STATES

PORTRAIT OF *AVATAR* CHARACTER, JAKE SULLY (PLAYED BY SAM WORTHINGTON) MADE FROM PASTA SOAKED IN GLOW IN THE DARK INK.

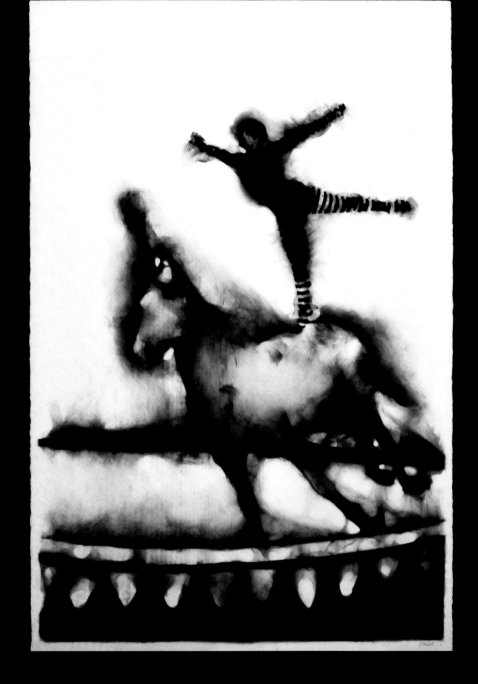

FLYING ALINGA BALANCING RING ROB TARBELL

ST. PETERSBURG, FLORIDA, UNITED ST

A CIRCUS SCENE DRAWN WITH SMOKE. TO ACHIEVE THIS, THE ARTIST HUNG A CANVAS OVERHE
DIRECTED THE SMOKE FROM BURNING ITEMS SUCH AS CREDIT CARDS, PHOTOS, AND 35 MM

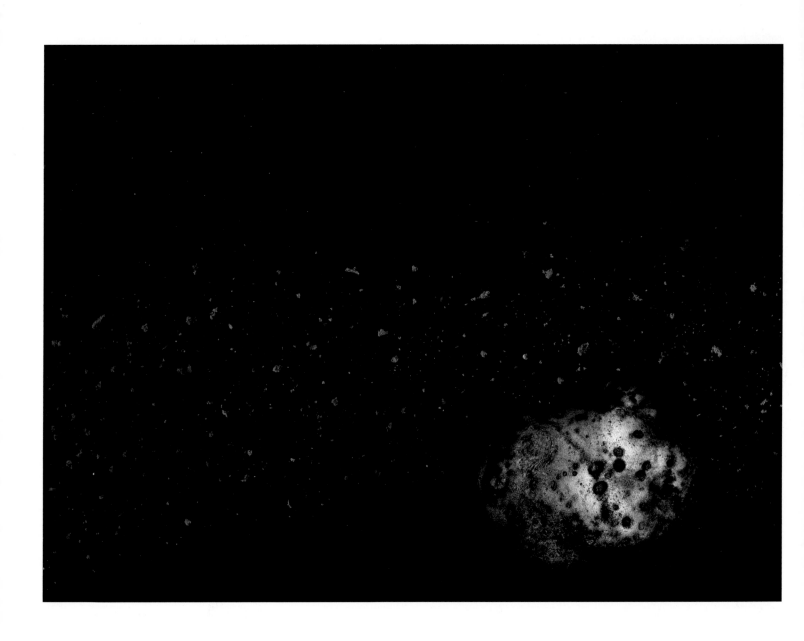

SPACE SCANS NAVID BARATY

WANDER SPACE PROBE

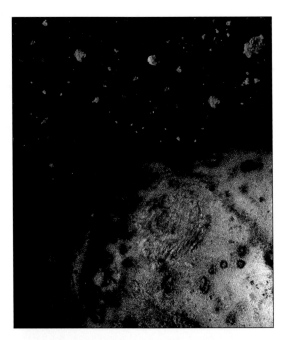

At first glance these images appear to be views through a telescope. However, the fictional *Wander Space Probe* series was created by photographer Navid Baraty by scanning food placed on a flatbed scanner while the lid is open.

> *"While they are purely fictional, I like to think that perhaps my creations actually could exist somewhere in the vast unknown of the cosmos."*

The asteroid image features a potato, coffee, peppercorns, and crumbled cookies. The eclipse was created using turmeric, powdered cheese, cinnamon, and baking soda.

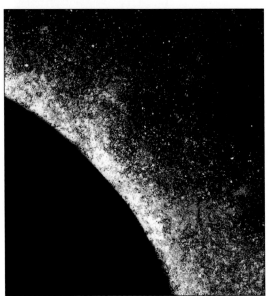

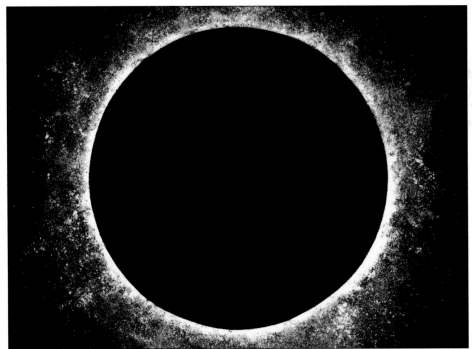

SEATTLE, WASHINGTON, UNITED STATES
CREATED IN A FLATBED SCANNER WITH THE LID UP, USING FOOD TO IMITATE SPACE SCENES.

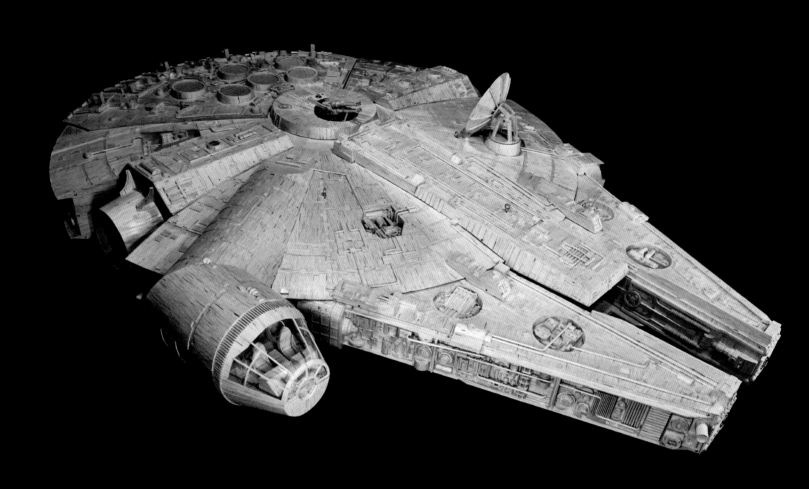

MATCHSTICK MILLENNIUM FALCON PATRICK ACTON

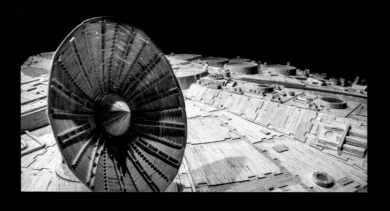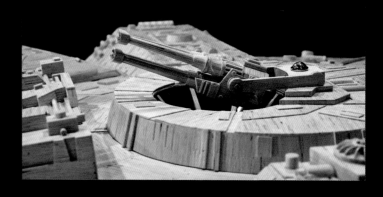

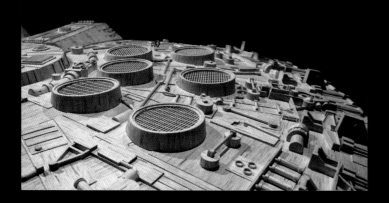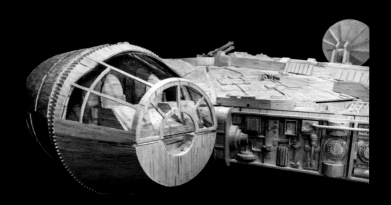

GLADBROOK, IOWA, UNITED STATES

THE FAMOUS STARSHIP FROM *STAR WARS* RECREATED WITH 910,000 MATCHSTICKS AND 26 GALLONS OF GLUE.
BROUGHT TO LIFE WITH SOUND, LIGHTING, AMD MOVEMENT. 6 x 15.3 x 12.6 FT (1.8 x 4.6 x 3.8 M), 450 LB (204 KG)

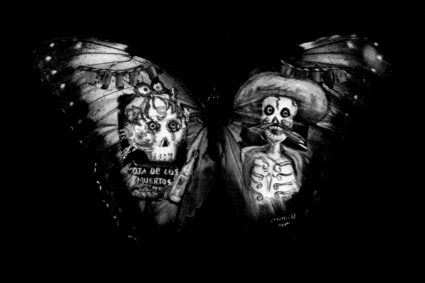
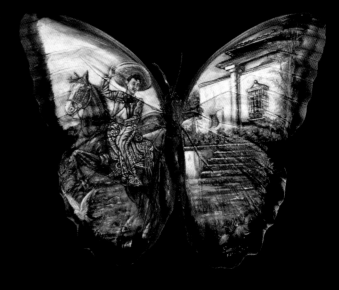
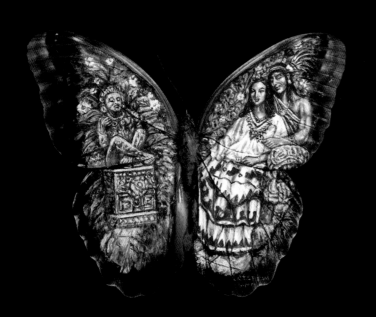
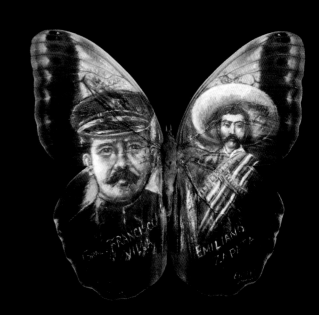

HISTORY OF MEXICO ENRIQUÉ RAMOS

MEXICO CITY, MEXICO

PART OF A SERIES OF 35 REAL BUTTERFLIES PAINTED WITH CULTURAL ICONS OF MEXICO. CLOCKWISE FROM TOP LEFT: DÍA DE LOS MUERTOS; A CHARRO; POPOCATÉPETL AND IZTACCÍHUATL; FRANCISCO "PANCHO" VILLA AND EMILIANO ZAPATA.

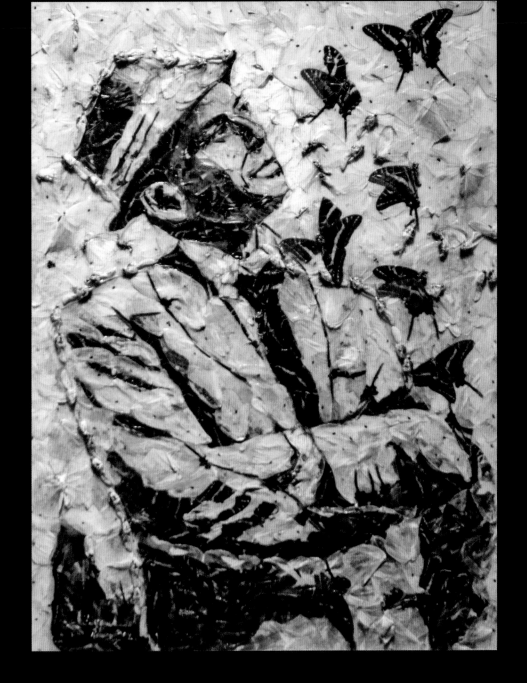

OLD BLUE EYES ENRIQUÉ RAMOS

MEXICO CITY, MEXICO

A COLLAGE OF FRANK SINATRA CREATED USING HUNDREDS OF BUTTERFLY WINGS AND NO PAINT

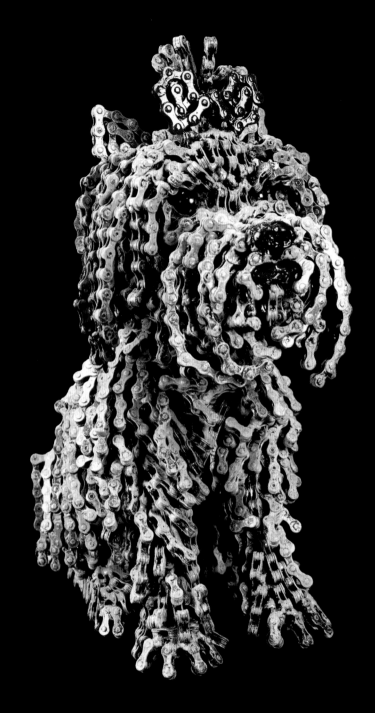

CHOO CHOO NIRIT LEVAV-PACKER

TEL AVIV, ISRAEL

DISCARDED BICYCLE CHAINS WELDED TOGETHER INTO A SCOTTISH TERRIER.
16 x 8 x 20 IN (40.6 x 20.3 x 50.8 CM)

78 ODD IS ART

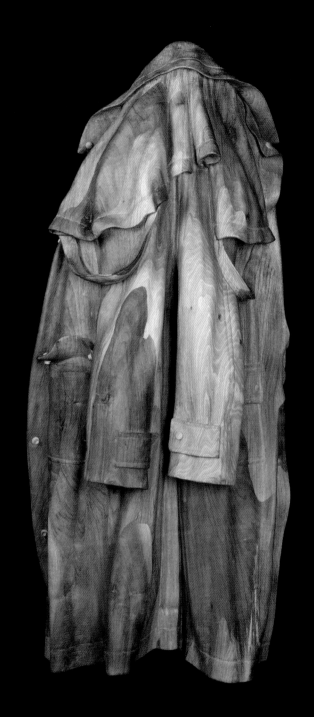

HEAVY COAT LIVIO DE MARCHI

VENICE, ITALY

FULL-SIZED WOOD CARVING OF A WRINKLED COAT, APPEARING TO HANG FROM A RACK.
48 x 21 x 10 in (122 x 53.3 x 25.4 cm)

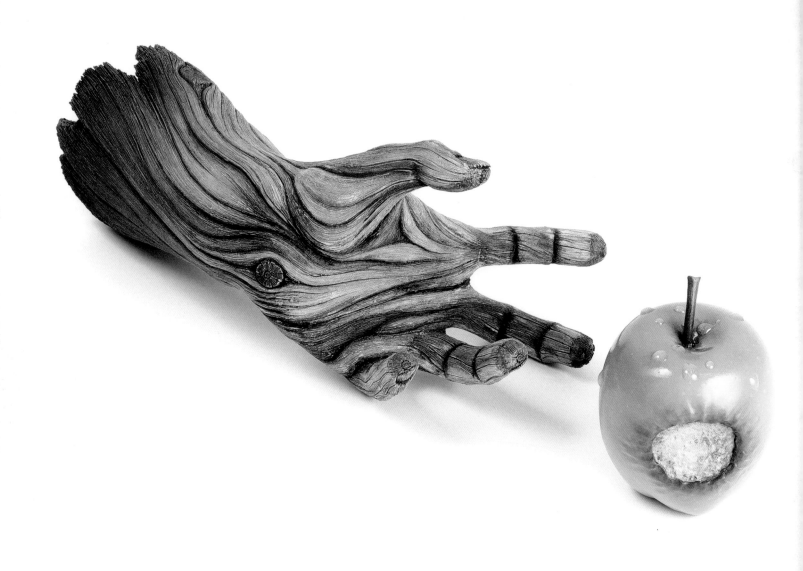

DOESN'T FALL FAR FROM THE TREE CHRISTOPHER DAVID WHITE

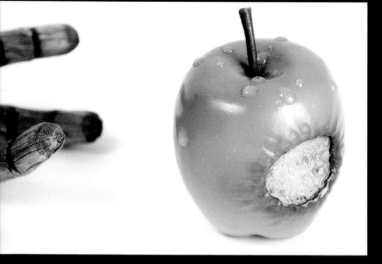

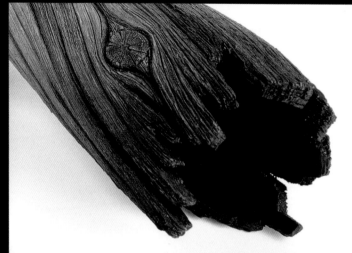

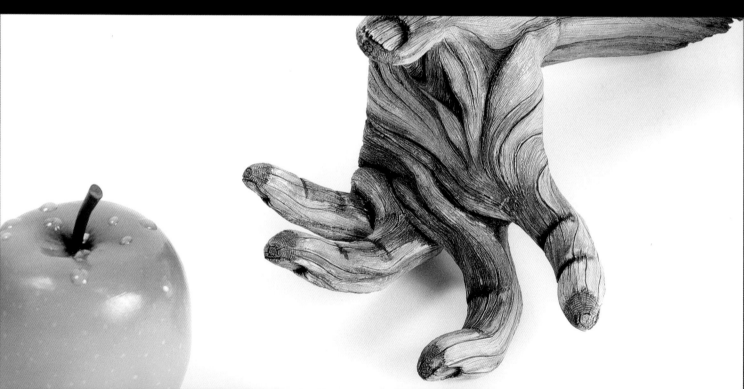

RICHMOND, VIRGINIA, UNITED STATES

HYPERREALISTIC CERAMIC SCULPTURE WITH ACRYLIC AND RESIN DETAILS
MADE TO LOOK LIKE A WOOD CARVING. 17.5 x 5 x 6.5 IN (44.5 x 12.7 x 16.5 CM)

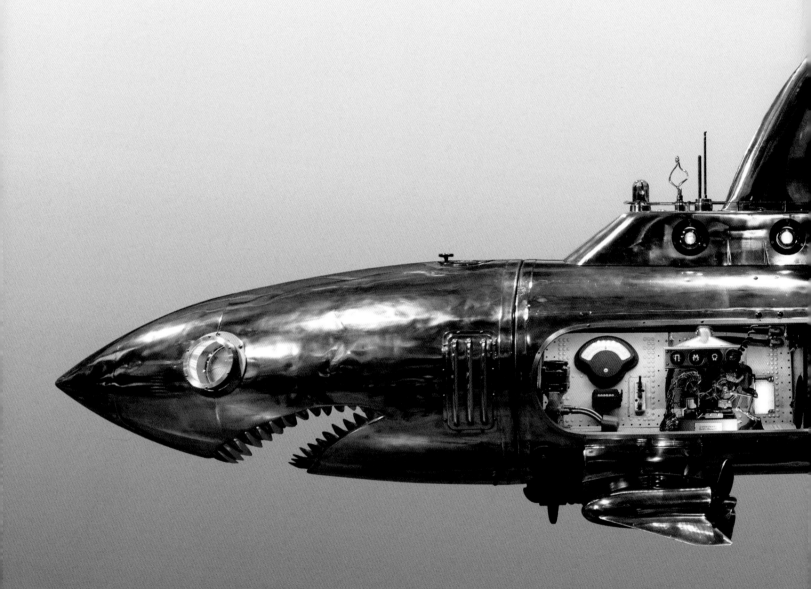

MEGALODON NEMO GOULD

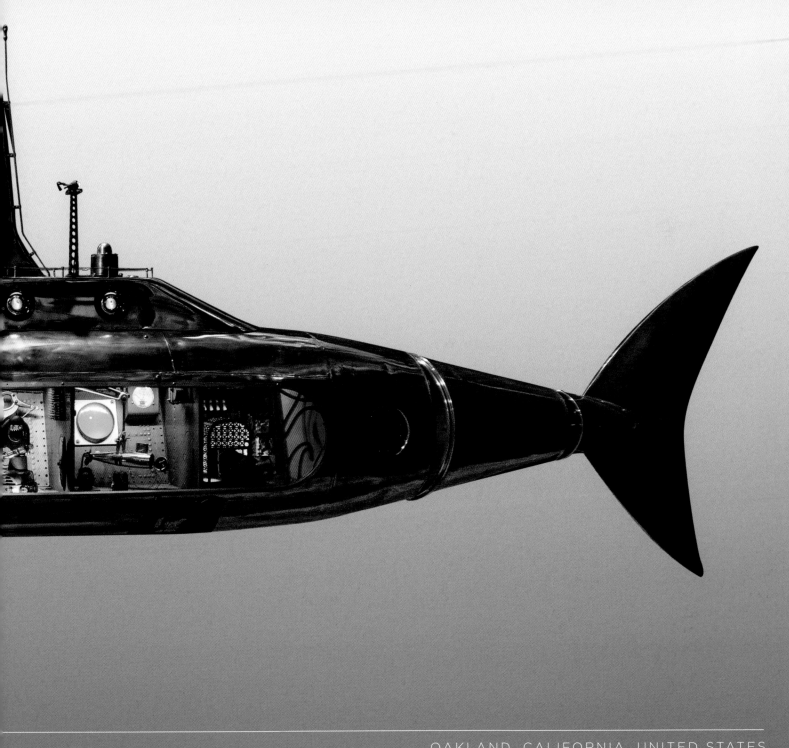

INSPIRED BY *20,000 LEAGUES UNDER THE SEA*, THE 16-FT-LONG (4.8-M) SHARK HAS A MOVING TAIL, GLOWING MOUTH, AND EYES THAT OPEN AND CLOSE. CRAFTED FROM A WORLD WAR II AIRPLANE FUSELAGE AND OBJECTS FOUND AT A CITY DUMP.

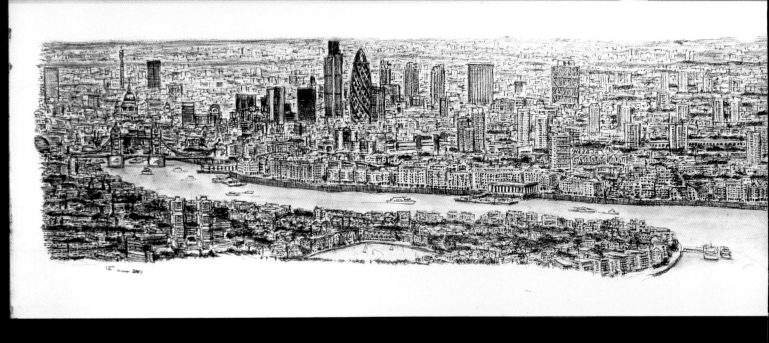

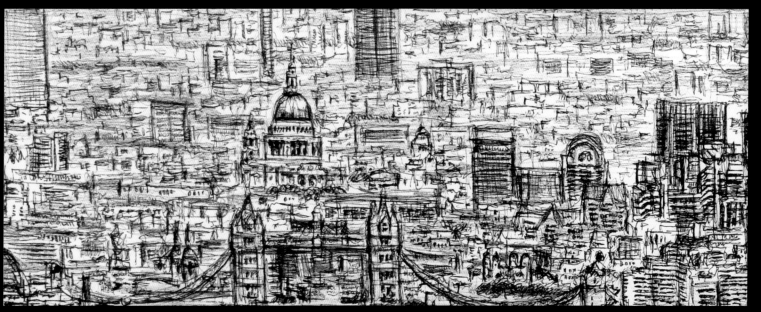

LONDON PANORAMA STEPHEN WILTSHIRE

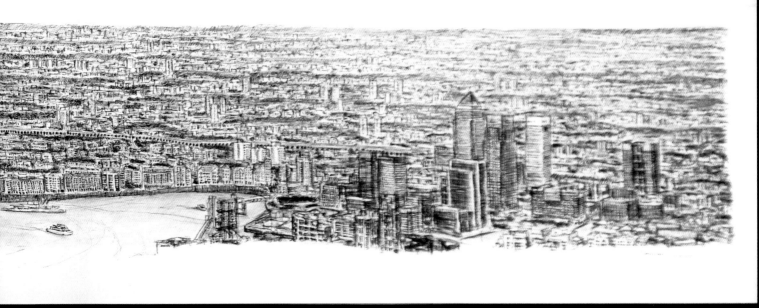

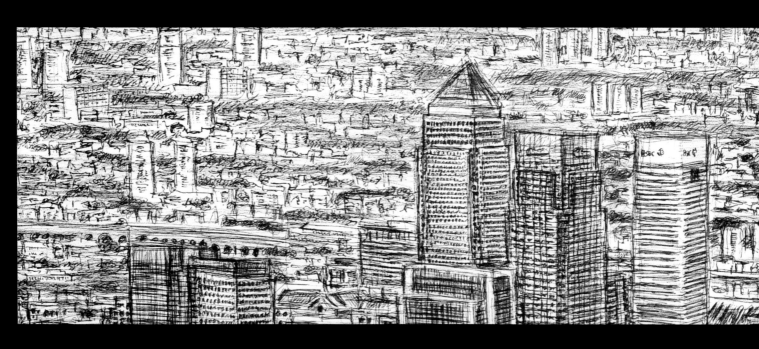

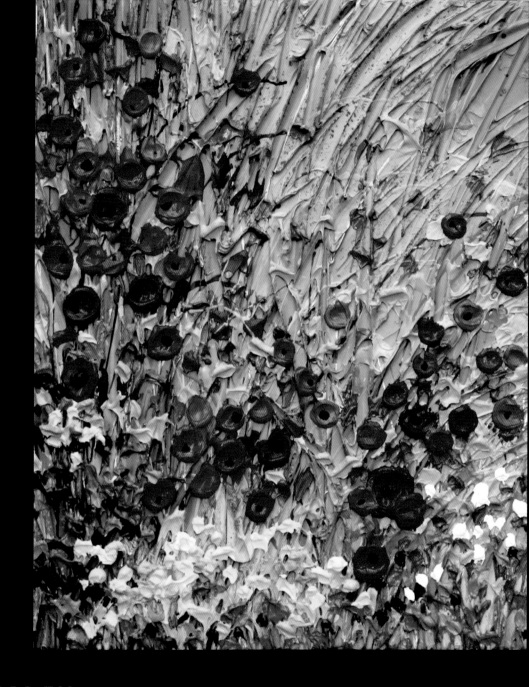

PAINTINGS BY JEFF HANSON

TOUCH THE ART

Jeffrey Owen Hanson of Overland Park, Kansas, has been visually impaired since childhood due to neurofibromatosis and an optic chiasm brain tumor. At the age of 12, he started painting notecards with watercolors as a way to pass the time during chemotherapy sessions. He gradually transitioned to heavily sculptured acrylic paintings, which have become his signature style. Now in his twenties, he enjoys a successful career as an artist and has used his skills to raise money for over 200 charities.

"Every act of kindness helps create kinder communities, more compassionate nations and a better world for all... even one painting at a time."

OVERLAND PARK, KANSAS, UNITED STATES

TACTILE PAINTINGS THAT ARE MEANT TO BE TOUCHED. SOME FEATURE ROPE, WOVEN STRIPS OF CANVAS, AND WIRE FOR ADDED TEXTURE.

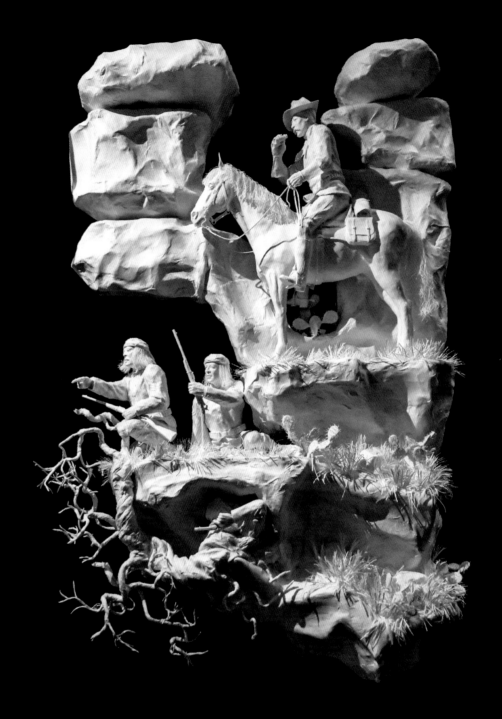

TRACKING GERONIMO ALLEN AND PATTY ECKMAN

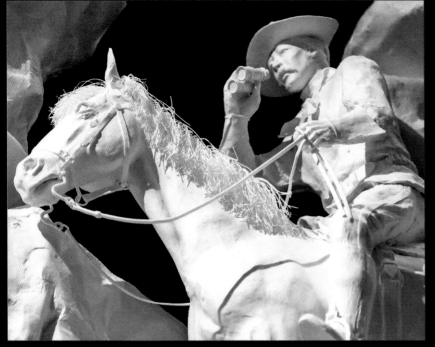

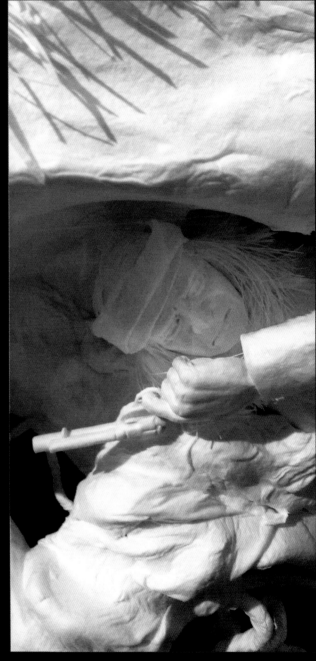

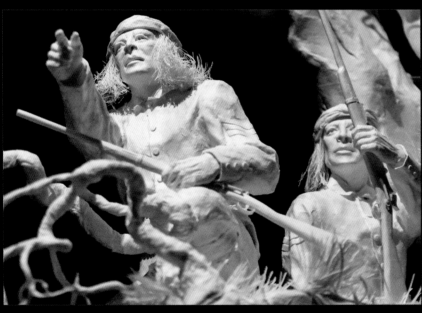

RAPID CITY, SOUTH DAKOTA, UNITED STATES

PAPER SCULPTURE OF U.S. CALVARY SOLDIERS SEARCHING FOR NATIVE AMERICAN LEGEND GERONIMO

3.6 x 5 FT (1.1 x 1.5 M

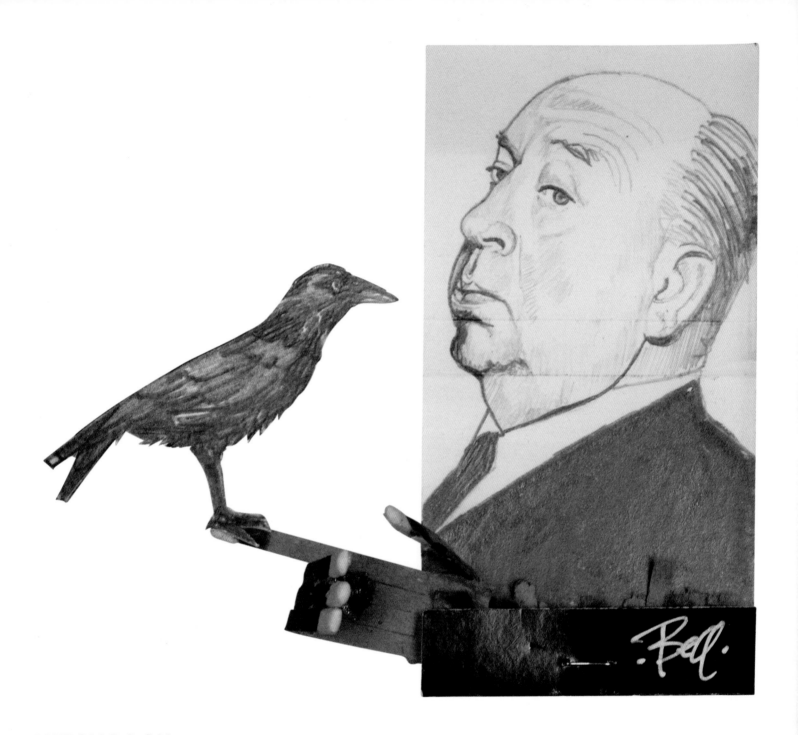

HITCHCOCK MIKE BELL

NORTHFIELD, NEW JERSEY, UNITED STATES
A LIFELIKE PENCIL PORTRAIT OF *THE BIRDS* DIRECTOR INSIDE A MATCHBOOK, INSIDE OF WHICH
SEVERAL MATCHES ARE ARRANGED TO LOOK LIKE A HAND HOLDING A BIRD. 4 x 2 in (10 x 5 cm)

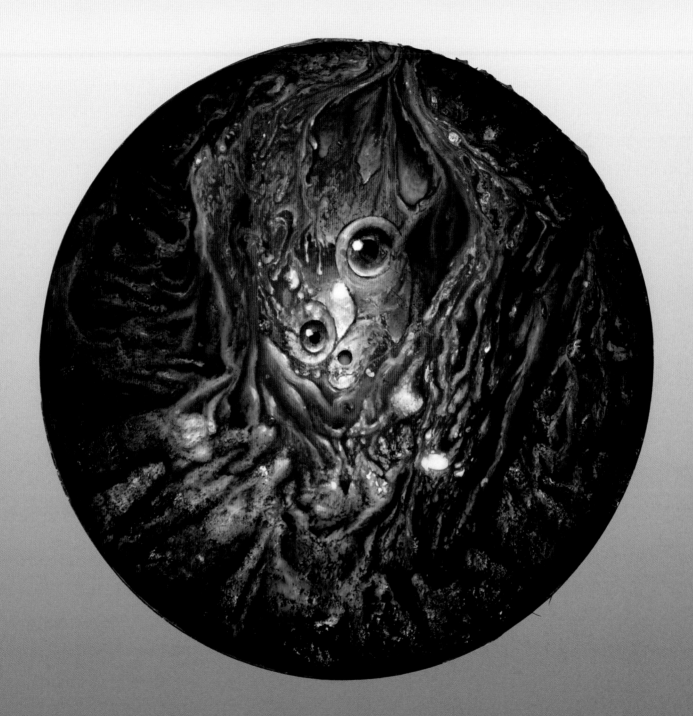

THE HAPQUATIC EYE FEST CARL INGRAM

PARAPARAUMU, NEW ZEALAND

OIL AND ACRYLIC PAINTS ON A VINYL RECORD, SPUN ON A OUIJA BOARD BALANCED
ON A FIDGET SPINNER. ONCE DRIED, SHADOWING AND DETAILS WERE ADDED. 12 IN (30.5 CM)

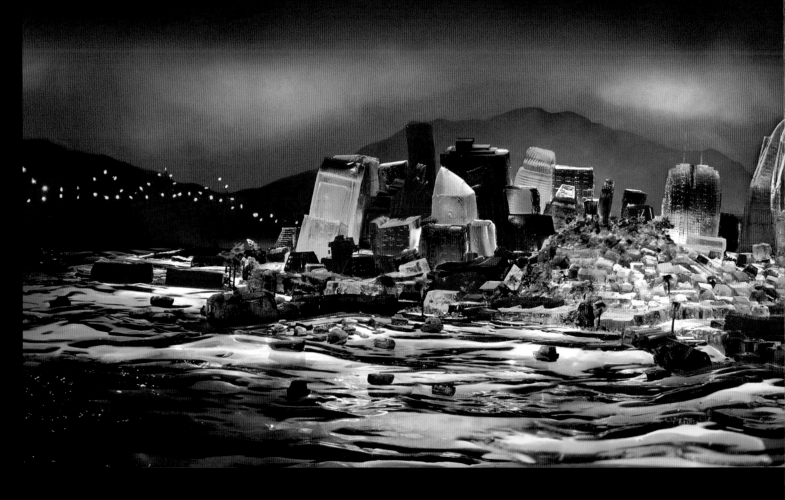

VIEW FROM ALCATRAZ LIZ HICKOK

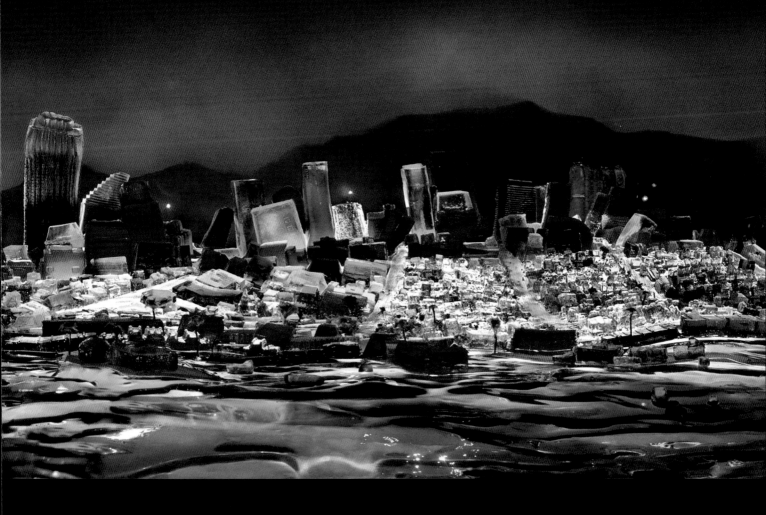

SAN FRANCISCO, CALIFORNIA, UNITED STATES

A SCENE OF SAN FRANCISCO CREATED WITH JELL-O, INSPIRED BY EARTHQUAKES THE CITY
EXPERIENCES AND A METAPHOR FOR THE TEMPORARY NATURE OF MAN-MADE CREATIONS

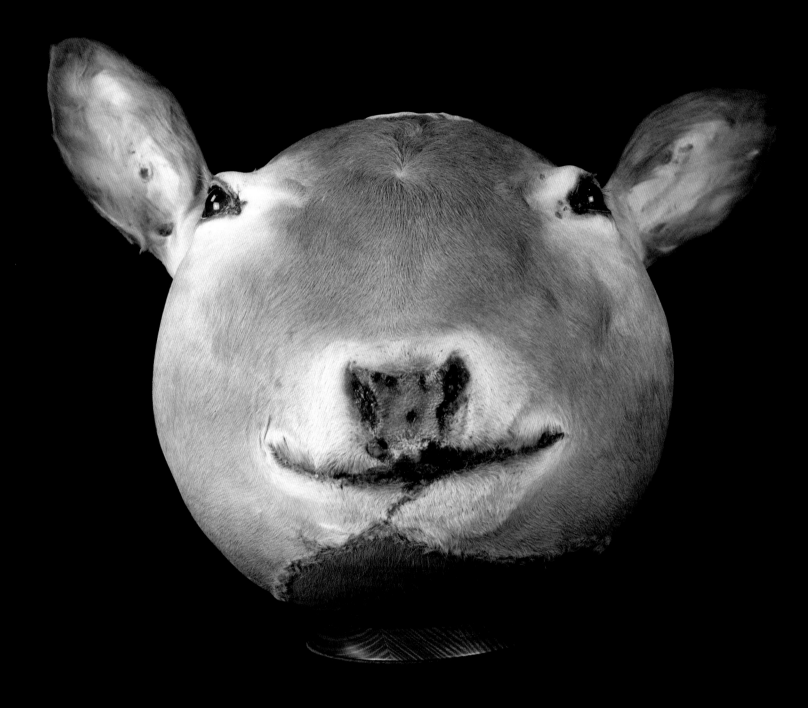

INFLATED TAXIDERMY GÉZA SZÖLLŐSI

BUDAPEST, HUNGARY

REAL COW'S HEAD THAT HAS BEEN RESHAPED INTO A SPHERE USING TRADITIONAL TAXIDERMY
TECHNIQUES, RESULTING IN A SURPRISINGLY LIGHT BALL. 19 x 13 x 21 IN (48.3 x 33 x 53.3 CM)

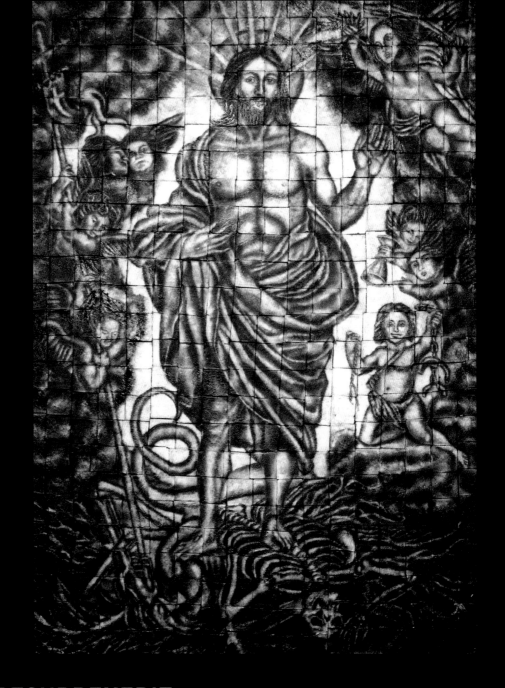

CHRISTO RESURREXERIT DALIA OSORIO

MCALLEN, TEXAS, UNITED STATES

IMAGE OF CHRIST RESURRECTED TOASTED ACROSS 425 SLICES OF BREAD BY USING COMMON HOUSEHOLD TOASTER AND HAND TORCH. THE ENTIRE PIECE IS LACQUERED TO PREVENT MOLDING. 5.2 x 7.1 FT (1.6 x 2.2 M

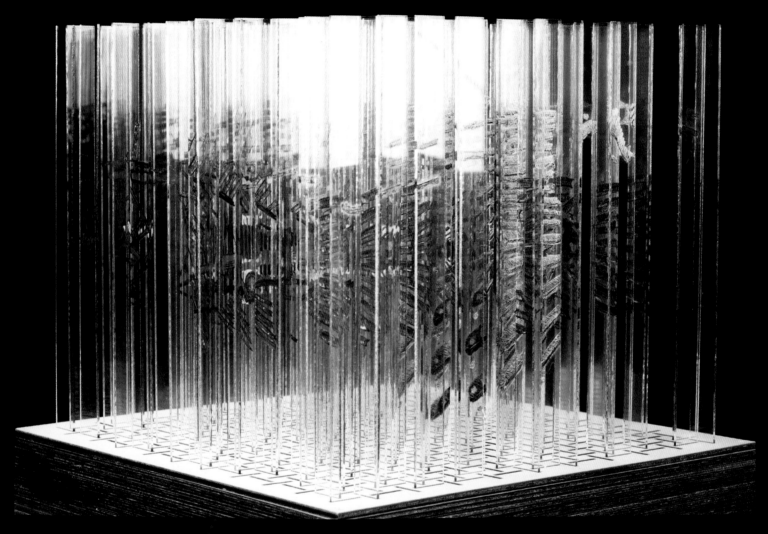

CORNER VIEW

EMULSIFIER THOMAS MEDICUS

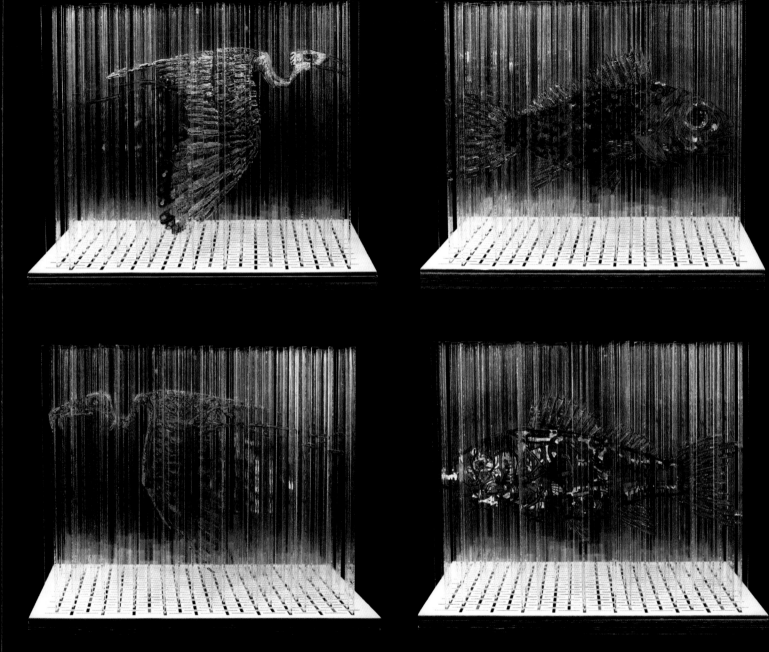

INNSBRUCK, AUSTRIA

160 HAND-PAINTED GLASS STRIPS ARRANGED TO CREATE A DIFFERENT
IMAGE ON EACH OF THE FOUR SIDES, 13.8 x 13.8 x 13.8 IN (35 x 35 x 35 CM)

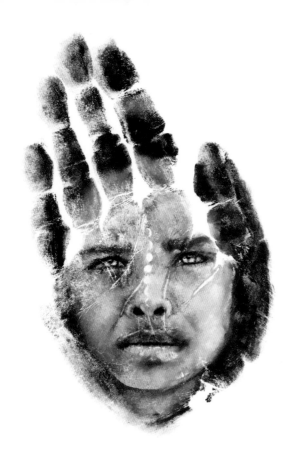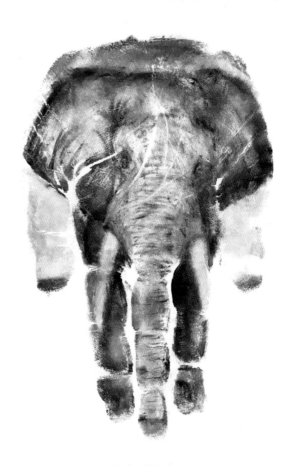

PALM PAINTINGS

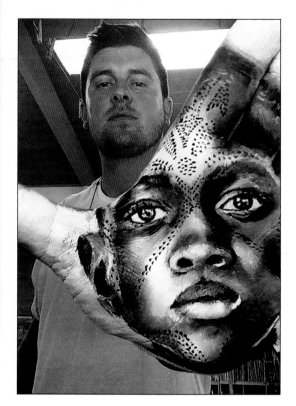

It took San Jose, California teacher and self-taught artist Russell Powell over two years to refine his unique style of art he calls "handstamping." By using secret techniques, he is able to paint an incredible amount of detail onto his palm before pressing it onto a canvas. When asked what he wants people to know about his art, Powell answered:

> *"There are a lot of causes that need attention, so I try to donate my work and include certain subjects as part of my work to shine a light on issues. . . Hopefully, it can help move the conversation forward and provoke people to talk about some of the things happening around all of us."*

Powell is also able to create large scenes and portraits out of multiple stampings—an incredible feat, considering he must paint a mirror image of what he wants the final image to be. The artist credits his elementary school students as a major source of inspiration.

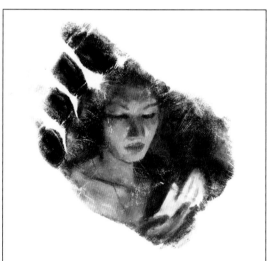

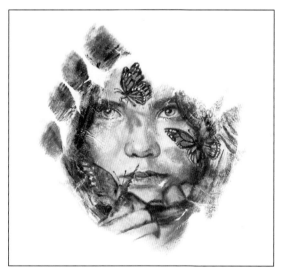

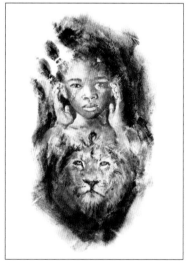

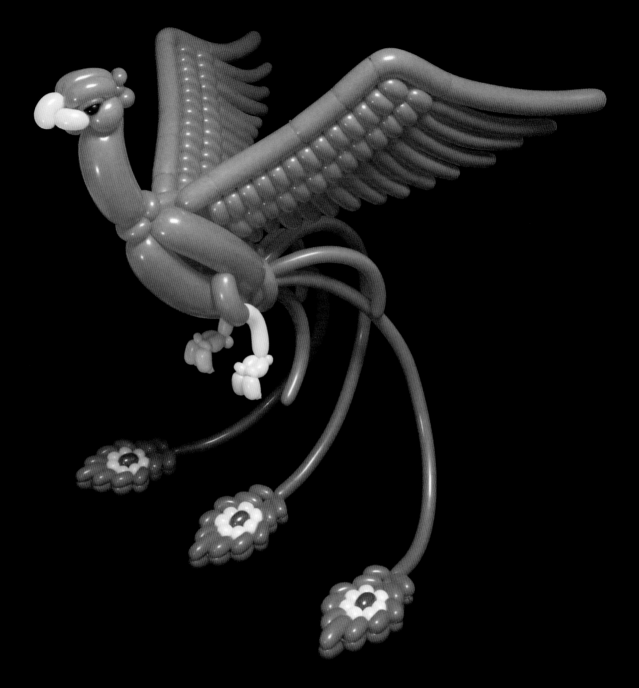

LATEX CREATURES MASAYOSHI MATSUMOTO

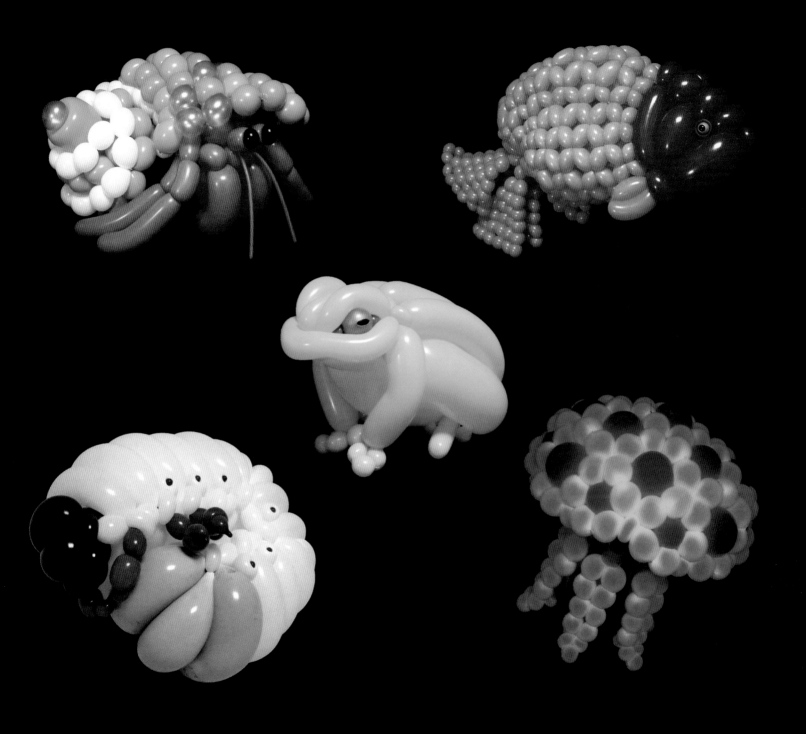

SAKURA, CHIBA, JAPAN

A COLLECTION OF BALLOON ANIMALS CREATED WITHOUT STRING, GLUE, OR MARKERS—BALLOONS ONLY.

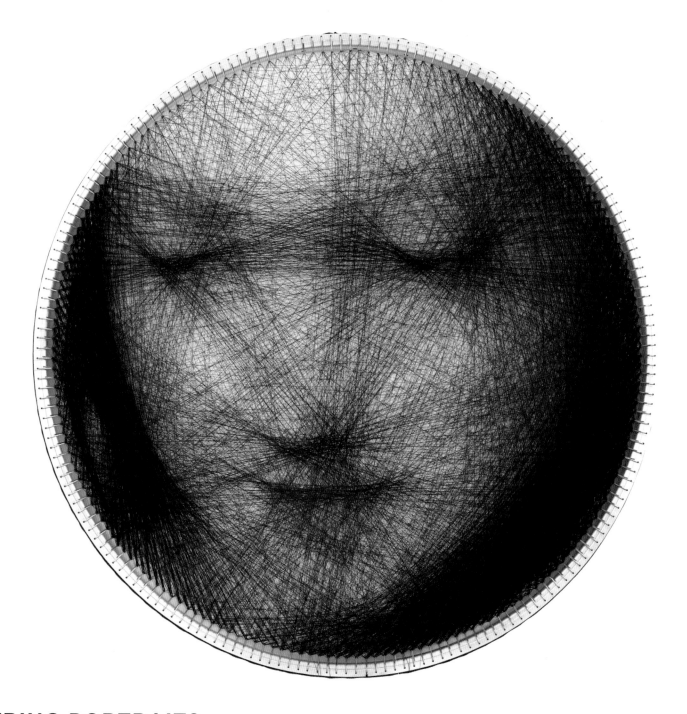

STRING PORTRAITS PETROS VRELLIS

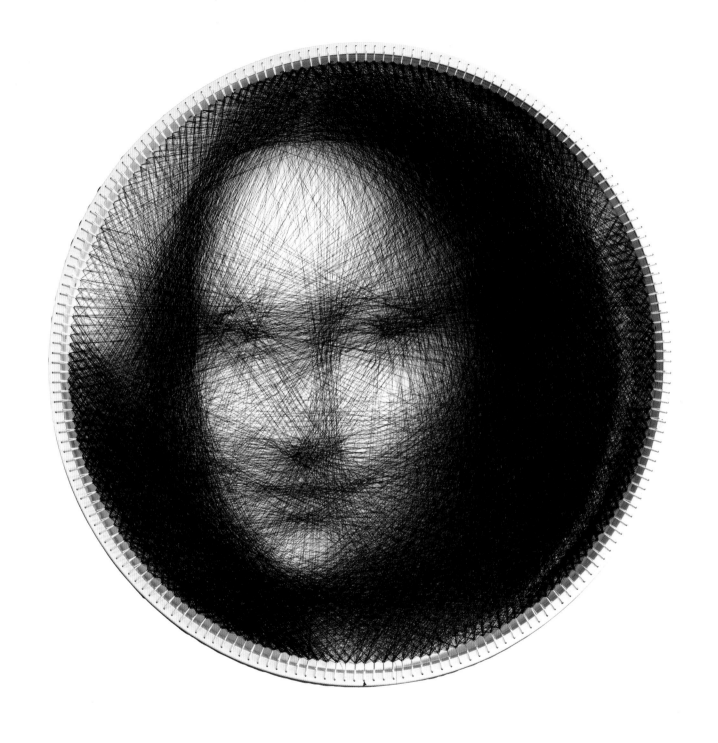

PREVEZA, GREECE

THOUSANDS OF STRAIGHT LINES OF THREAD ON A CIRCULAR LOOM ARE HAND-STRUNG BY THE ARTIST, WHO IS GUIDED BY A COMPUTER ALGORITHM, TO RECREATE CLASSIC PORTRAITS. USING THE ALGORITHM, THE ARTIST CAN RECREATE ANY IMAGE.

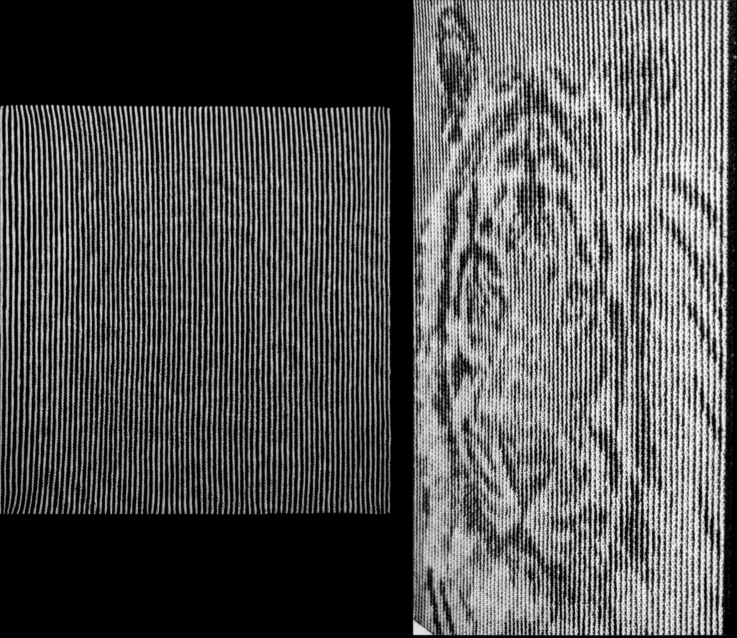

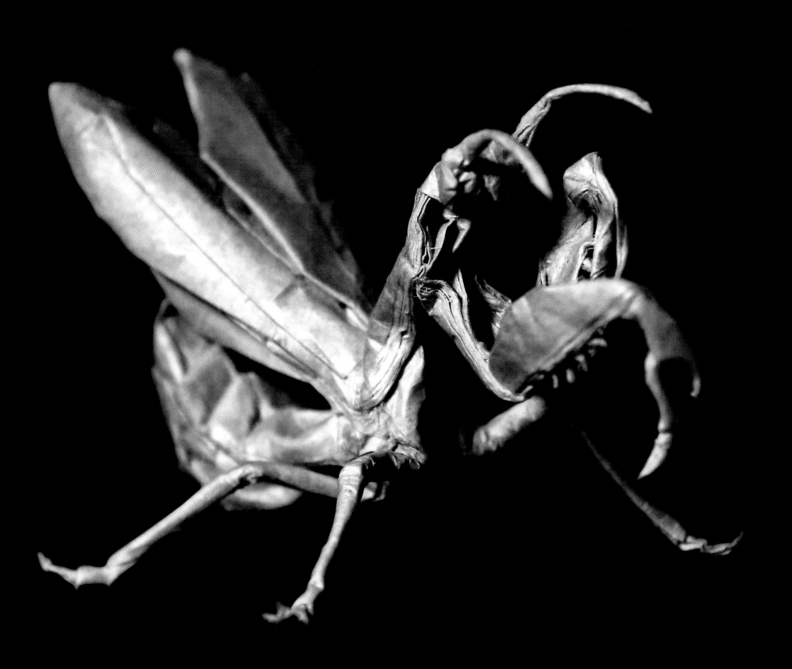

PAPER MANTIS QIN KUN

GUILIN, CHINA

ORIGAMI PRAYING MANTIS FOLDED FROM ONE SQUARE SHEET OF PAPER
AND WITHOUT THE USE OF SCISSORS OR GLUE. 2 x 4 IN (5.1 x 10.2 CM)

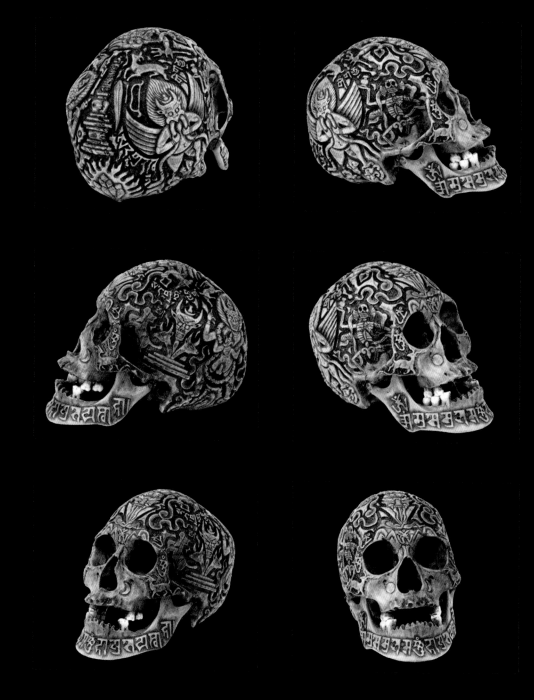

CARVED SKULL

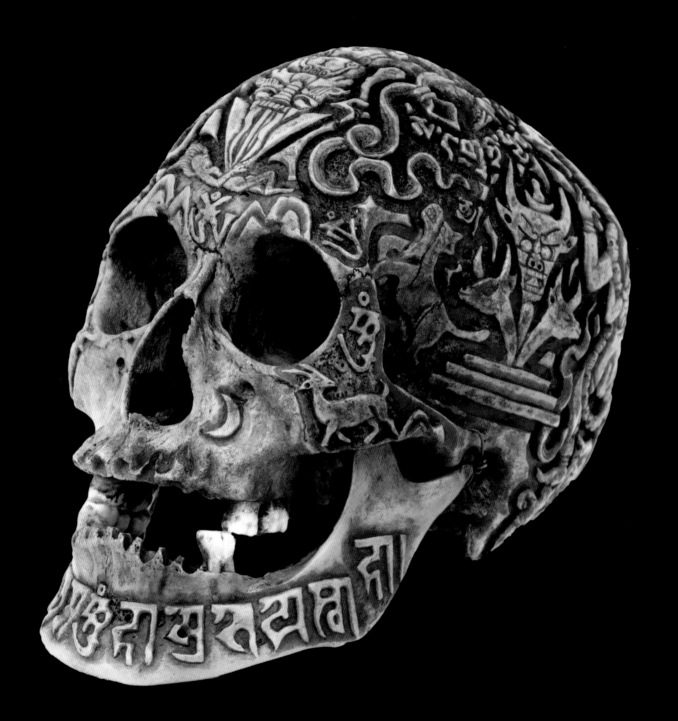

TIBET

IN TIBET, THE BONES OF DECESASED LOVED ONES WERE OFTEN
DECORATED AND REPURPOSED AS A SIGN OF UTMOST RESPECT.

MAGIC *Etch A Sketch®* SCREEN

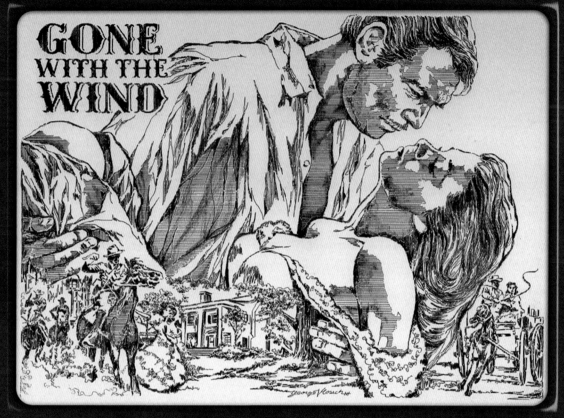

GONE WITH THE WIND GEORGE VLOSICH

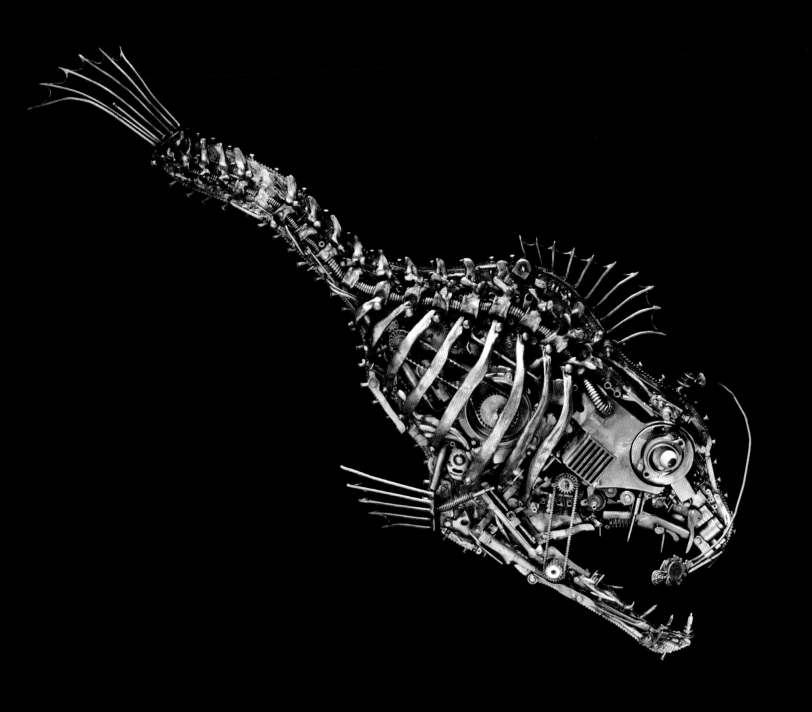

AVARECO JUD TURNER

EUGENE, OREGON, UNITED STATES
ANGLER FISH CREATED FROM METAL AND PLASTIC PIECES RECYCLED FROM HOUSEHOLD OBJECTS.
4 x 1.8 x 0.6 FT (1.2 x 0.6 x 0.2 M)

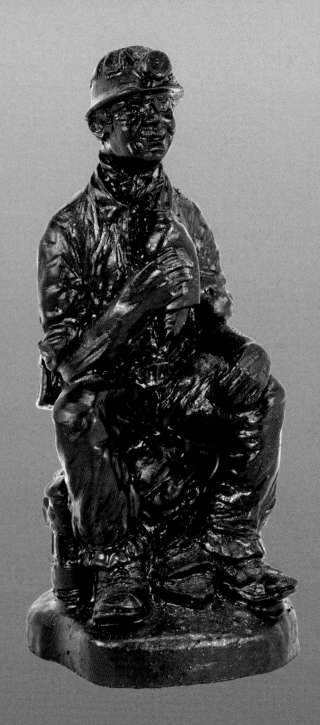

SITTING MINER COLIN TELFER

CUMBRIA, ENGLAND

A GRINNING MINER HOLDING A CANTEEN CARVED FROM COMBUSTIBLE LIGNITE COAL.
2 x 2 x 6 IN (5.1 x 5.1 x 15.2 CM)

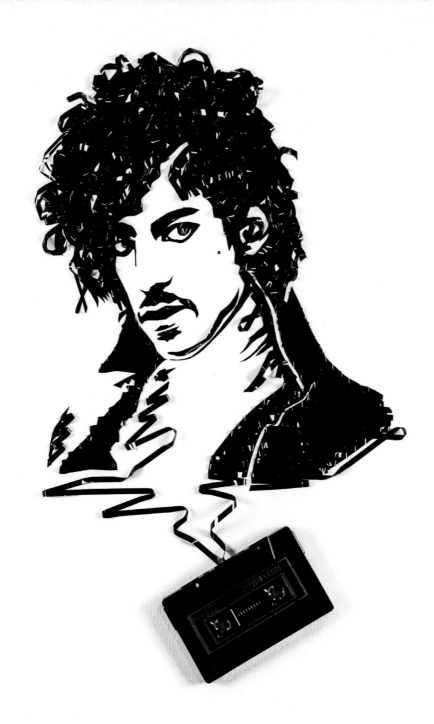

PRINCE ERIKA IRIS SIMMONS

ARLINGTON HEIGHTS, ILLINOIS, UNITED STATES
PART OF THE ARTIST'S *GHOST IN THE MACHINE* SERIES, WHICH SEES PORTRAITS OF
POP CULTURE ICONS RECREATED WITH AUDIO CASETTE TAPES OR FILM REELS. 24 x 18 IN (61 x 45.7 CM)

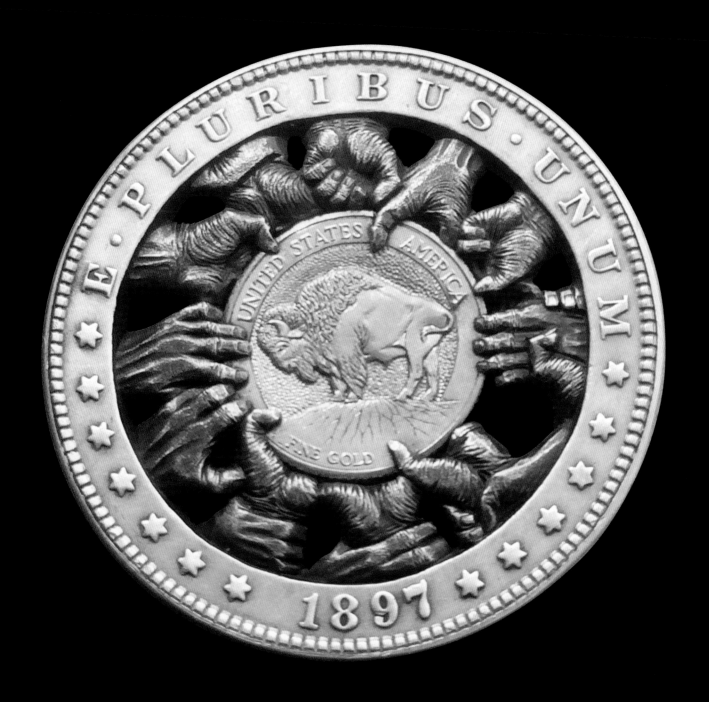

WORSHIP OF THE GOLDEN CALF ROMAN BOOTEEN

YEKATERINBURG, RUSSIA

THE ART OF CARVING COINS HAS BEEN AROUND FOR HUNDREDS OF YEARS, BUT IS RARELY THIS EXTENSIVE. THIS PIECE WAS ORIGINALLY A MORGAN SILVER DOLLAR. 1.5 IN (3.8 CM)

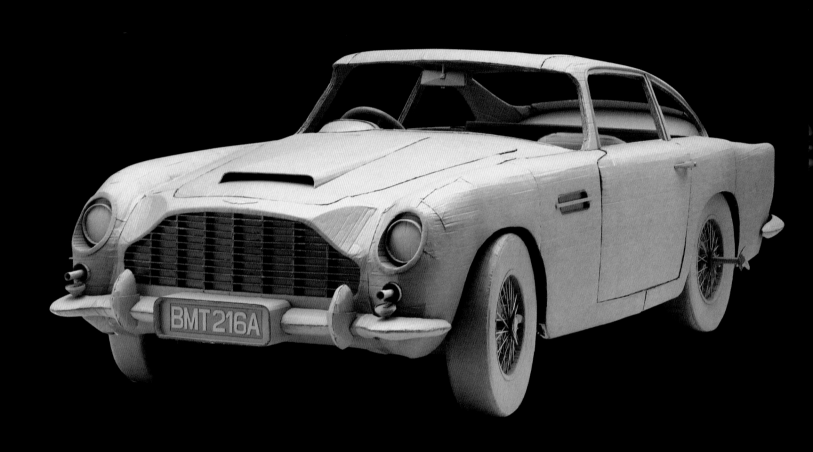

ASTON MARTIN DB5 CHRIS GILMOUR

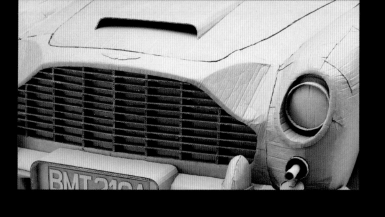
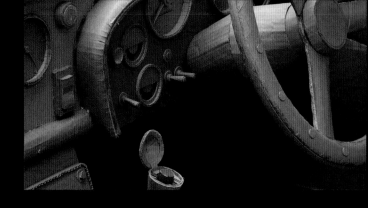
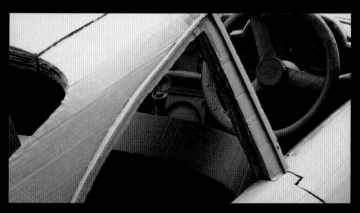
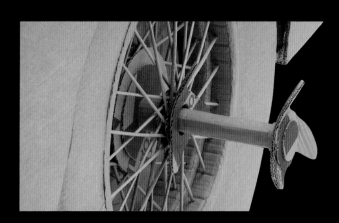

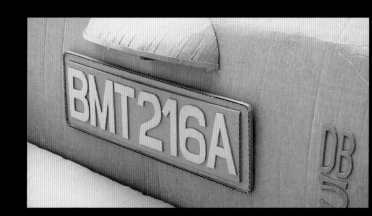

UDINE, ITALY

LIFE-SIZED RECREATION OF JAMES BOND'S CAR AS SEEN IN THE MOVIES *GOLDFINGER*
AND *THUNDERBALL* MADE COMPLETELY OUT OF RECYCLED CARDBOARD AND GLUE.

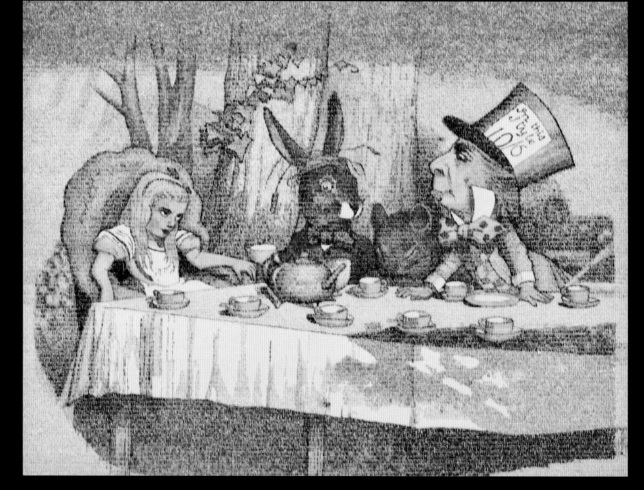

THE MAD HATTER'S TEA PARTY RICK ALMANSON

LOS ANGELES, CALIFORNIA, UNITED STATES

THE FIRST FOUR CHAPTERS OF LEWIS CARROLL'S *ALICE IN WONDERLAND* HAND-WRITTEN TO FORM
THIS SCENE. THE ARTIST IS LEFT-HANDED AND WROTE UPSIDE DOWN TO AVOID SMUDGING LETTERS.

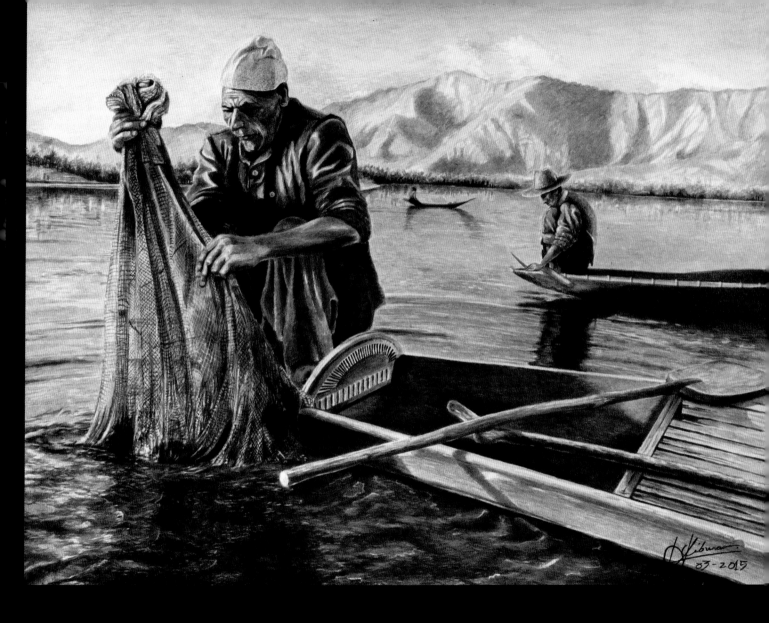

HARVESTING LAUREN MARK LIBUNAO

MANILA, PHILIPPINES

PAINTED WITH LAYERS OF GARLIC OIL. THE ARTIST CREATED AN ORGANIC PRESERVATIVE
THAT GIVES THE ARTWORK A SHELF LIFE OF 50 YEARS. 22 x 27 IN (55.9 x 68.6 CM

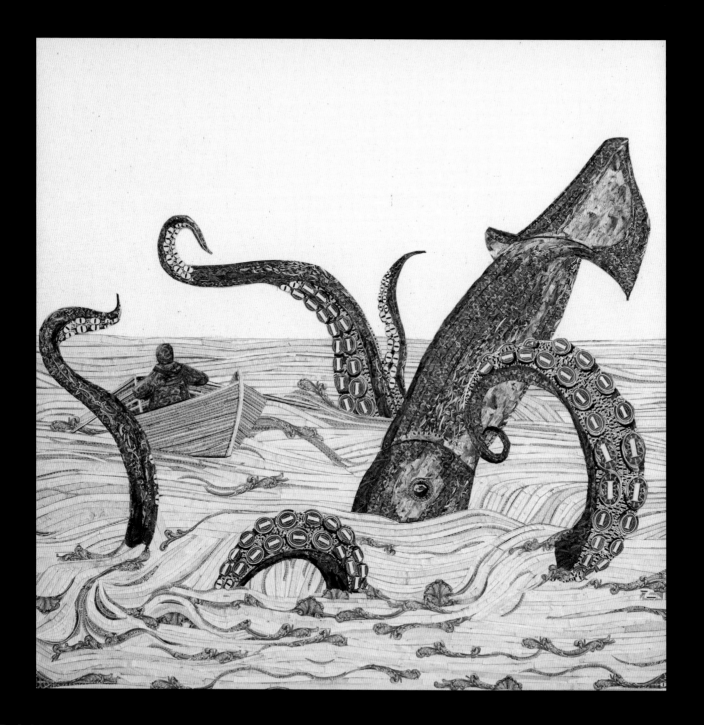

KRAKEN CHAD PERSON

ALBUQUERQUE, NEW MEXICO, UNITED STATES
U.S. CURRENCY CUT UP AND REARRANGED INTO A SCENE ON THE HIGH SEAS.
PART OF THE ARTIST'S *HERE THERE BE MONSTERS* SERIES. 16 x 16 IN (40.6 x 40.6 CM)

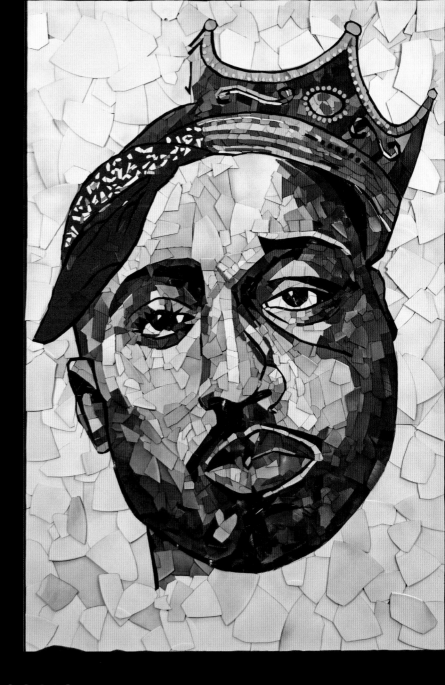

RECORD MOSAIC ED CHAPMAN

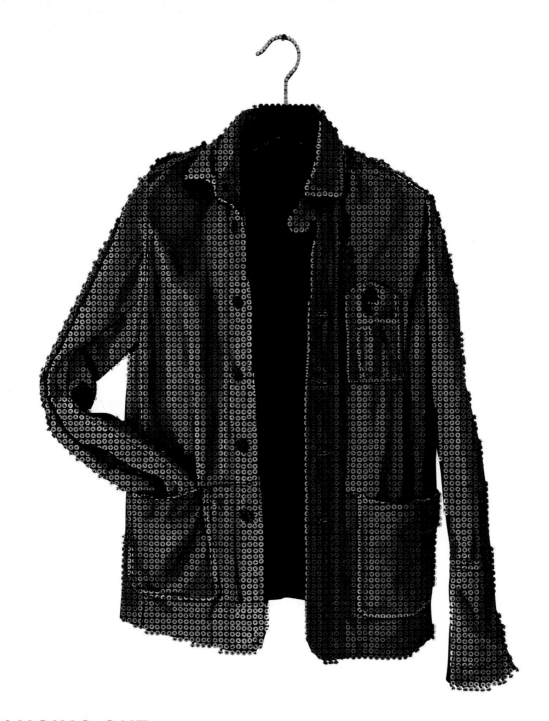

JUST HANGING OUT ANDREW MYERS

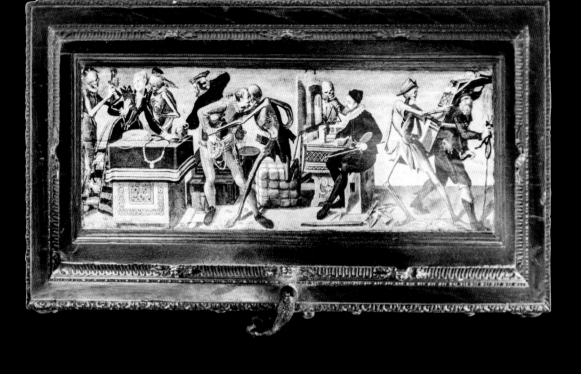
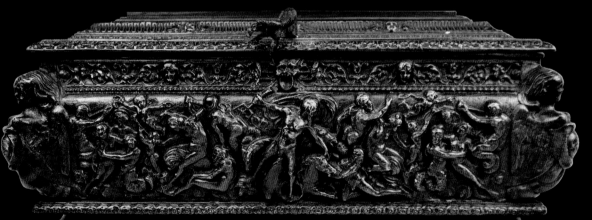

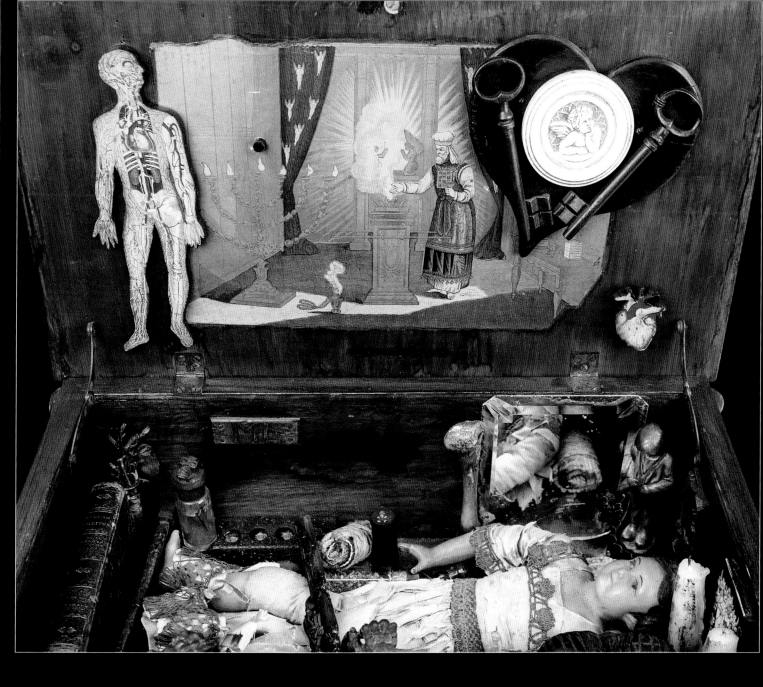

FRANCE

SEVENTEENTH-CENTURY WOODEN BOX WITH APOCALYPTIC CARVINGS AND AN ILLUSTRATION OF PEOPLE SOCIALIZING WITH DEATH. INSIDE IS A PRAYER BOOK, A MIRROR, MODEL HEART AND ANATOMY FIGURES, AND A WAX DOLL.

SALT LICK SCULPTURES

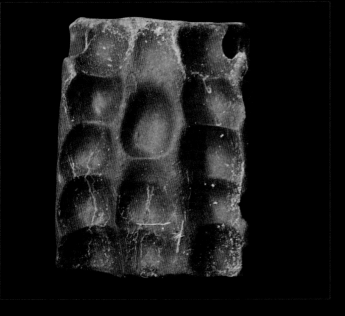

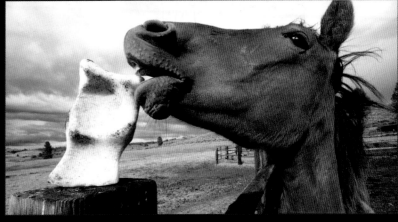

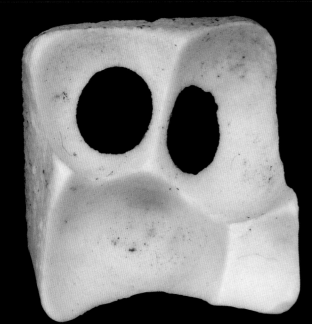

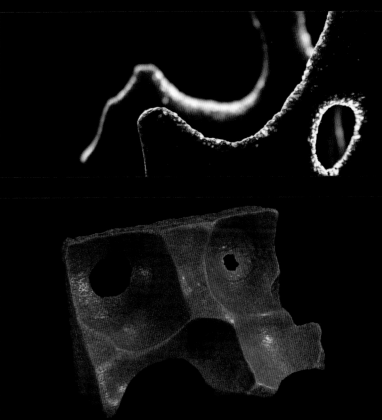

BAKER CITY, OREGON, UNITED STATES

FIFTY-POUND BLOCKS OF SALT LICKED INTO ABSTRACT SHAPES BY COWS, HORSES, AND DEER ARE AUCTIONED
TO BENEFIT PARKINSON'S RESEARCH AT THE ANNUAL GREAT SALT LICK CONTEST STARTED BY WHIT DESCHNER

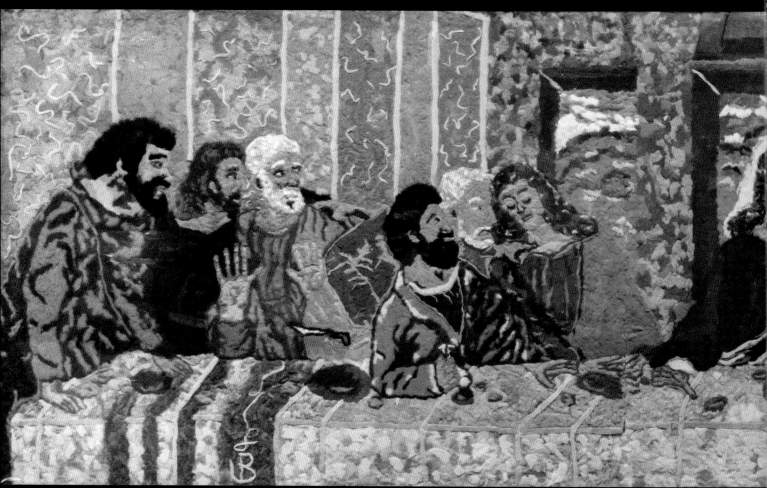

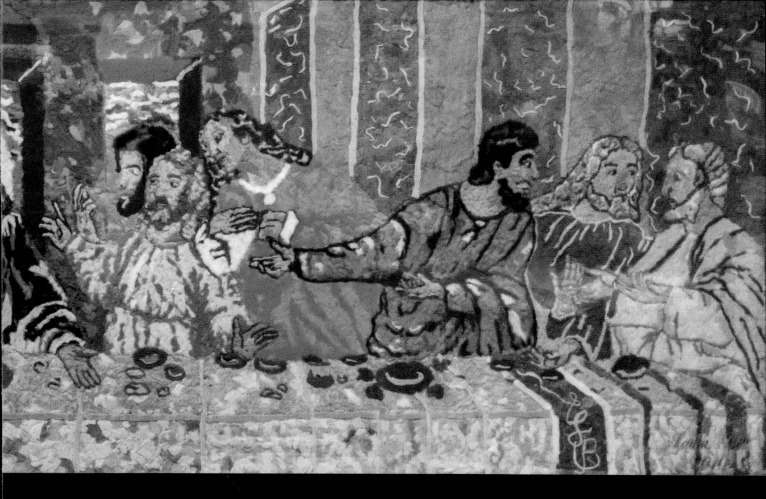

THE ARTIST WOULD DRY SPECIFIC PIECES OF CLOTHING
IN ORDER TO OBTAIN THE CORRECT COLOR OF LINT

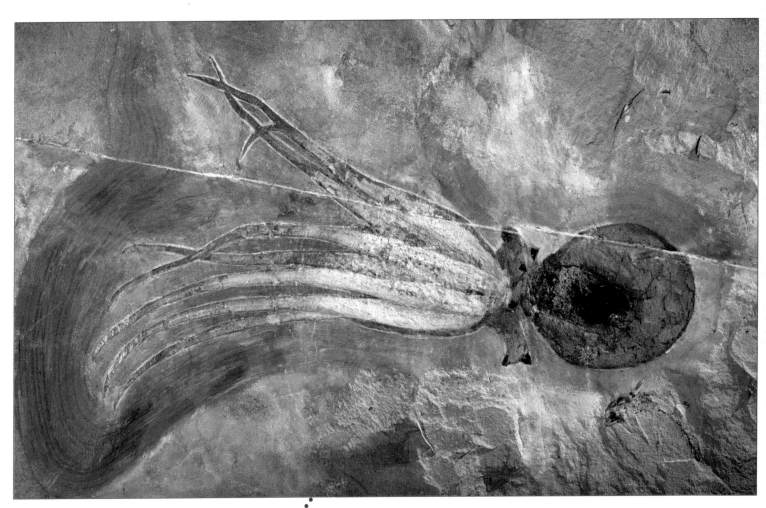

THE FOSSIL THE PAINTING WAS BASED ON
AND FROM WHICH THE INK WAS EXTRACTED.

95 MILLION YEARS LATER ESTHER VAN HULSEN

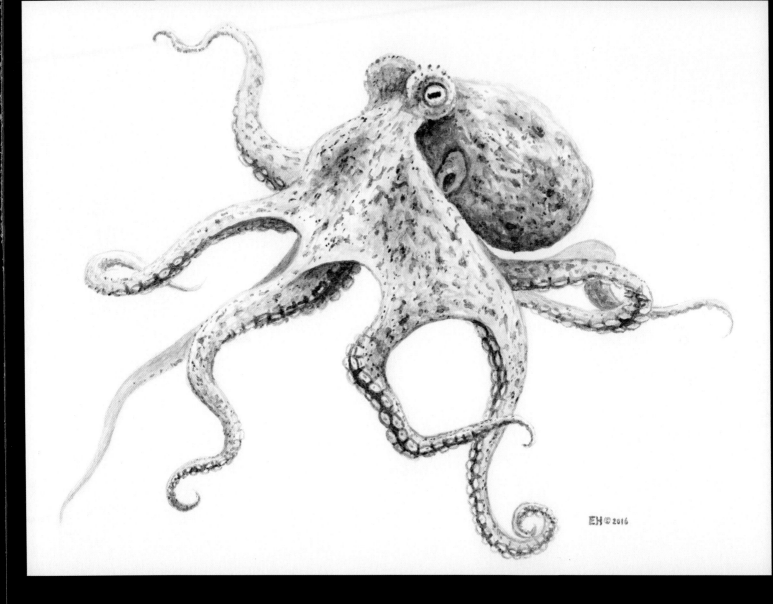

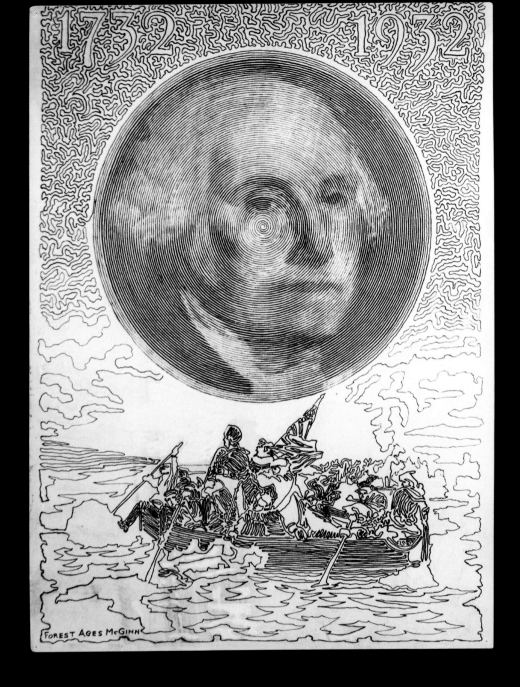

ONE LINE FOREST AGES MCGINN

ORIGIN UNKNOWN

A COMBINATION OF GILBERT STUART'S PORTRAIT OF GEORGE WASHINGTON AND EMANUEL LEUTZE'S
WASHINGTON CROSSING THE DELAWARE DRAWN WITHOUT LIFTING THE PENCIL FROM THE PAGE. 11.5 x 8.8 IN (29.2 x 22.2 CM)

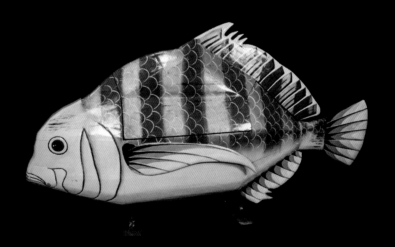

FANTASY COFFINS PAA JOE

GHANA, WEST AFRICA

A COLLECTION OF EXTRAVAGANT CUSTOM COFFINS,
MEANT TO REPRESENT THE LIFE OF THE DECEASED.

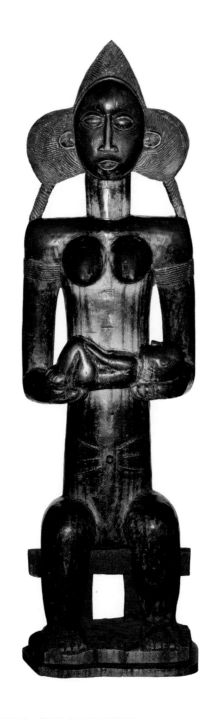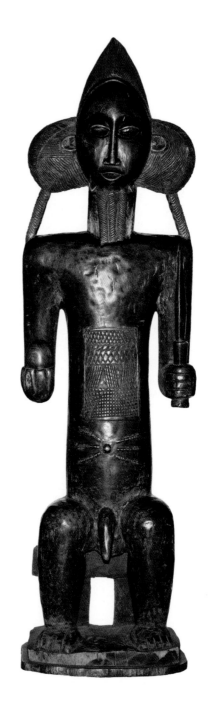

FERTILITY STATUES

CONCEIVE IT OR NOT

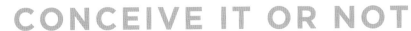

Acquired by Ripley's in 1993, this pair of fertility statues has been credited with helping thousands of women become pregnant.

The set includes a male and female, with the woman holding a baby and the man holding a mango and a spear—symbols of fertility. The statues are meant to be placed on either side of a bedroom doorway. Legend says that a woman and her spouse hoping to conceive should touch the statues as they enter the room.

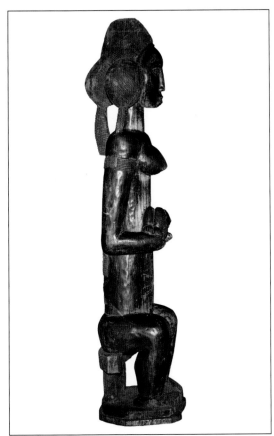

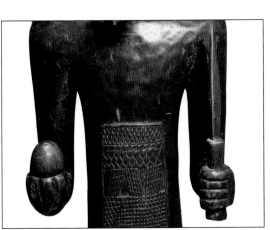

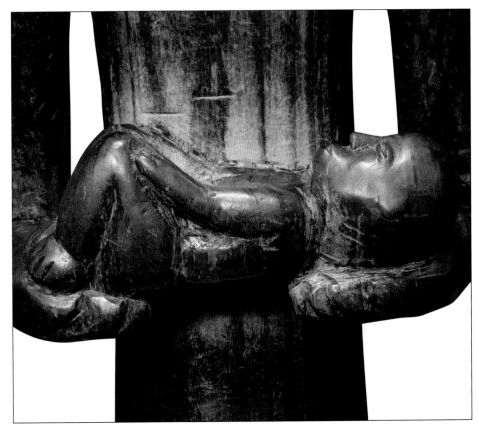

COTE D'IVOIRE, WEST AFRICA

HAND-CARVED OUT OF EBONY BY BAULÉ TRIBESMAN IN THE 1930S.
EACH STATUE STANDS 5 FT (1.5 M) TALL AND WEIGHS OVER 70 LB (31.6 KG).

GIANT PACIFIC OCTOPUS JEFFREY MICHAEL SAMUDOSKY

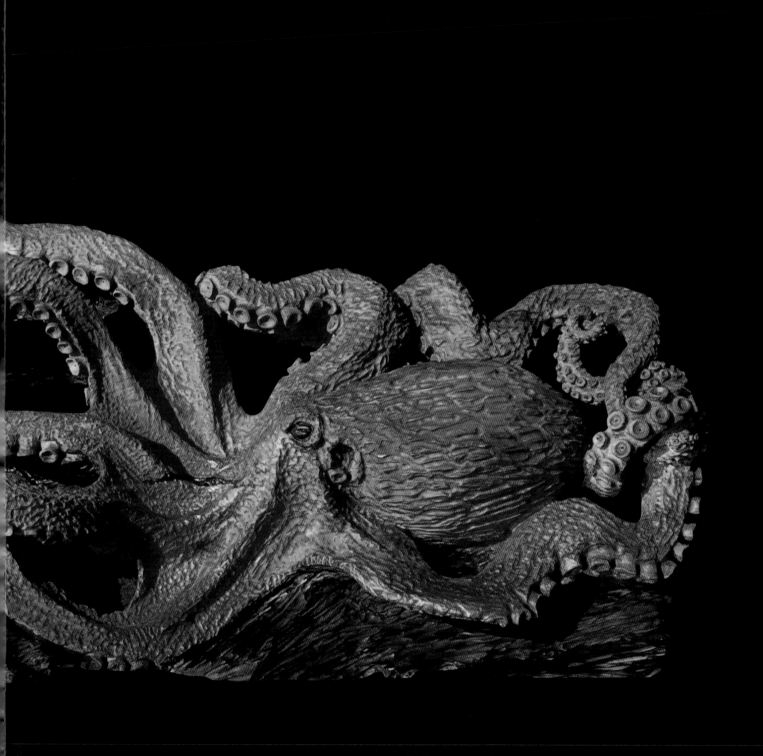

GIG HARBOR, WASHINGTON, UNITED STATES

CARVED WITH A CHAINSAW FROM A SINGLE, MASSIVE REDWOOD BURL. THE BACKGROUND
WAS BURNED TO ACHIEVE THE DARK BROWN COLORING. 14 x 9 ft (4.3 x 2.7 m), 3,500 lb (1,590 kg)

INDEX

Items and artists noted with an asterisk* can be found within the Ripley collection.

ACKNOWLEDGEMENTS

Cover Paul A. Baliker **14-15** Paul A. Baliker **16** Carol Milne **17** LISA NILSSON / JOHN POLAK / CATERS NEWS **26-27** Chris "Hairculese" Rider **30** STEVEN KUTCHER / CATERS NEWS **34-35** Michael Papadakis @Sunscribes **36** "The Old Ways" by Brittany Cox **42** LIU BOLIN / CATERS NEWS **43** LI HONGBO/KLEIN SUN GALLERY/CATERS NEWS **46-47** Photos by Gregory Halili **49** Cover Images **53** AP Photo/Robert E. Klein **56** Riusuke Fukahori/Solent News/REX/Shutterstock **57** Riusuke Fukahori/Solent News/REX/Shutterstock **59** Supplied by WENN.com **60** Darren Pearson/REX/Shutterstock **61** MERCURY PRESS/CATERS **62-63** José Manuel Castro López **64** Nicky James Burch and Lauren LaRee **65** THE AMERICAN SOCIETY FOR MICROBIOLOGY/MERCURY PRESS **66-67** Dino Tomic. Instagram: @dinotomic. Facebook: AtomiccircuS **72-73** Navid Baraty **80-81** Artworks by Christopher David White with images provided by Marta Finkelstein **86-87** Jeffrey Owen Hanson www.JeffHansonArt.com **91** Carl Ingram **92-93** Liz Hickok **98-99** Russell Powell @pangaeanstudios **100-101** Masayoshi Matsumoto **102-103** Petros Vrellis (http://artof01.com/vrellis/) **105** Xinhua / Alamy Stock Photo **108** GEORGE VLOSICH / CATERS NEWS **113** Cover Images **118** CHAD PERSON / CATERS NEWS **120-121** Andrew Myers Art **124-125** Whit Deschner **128-129** Esther van Hulsen **134-135** Jeffrey Michael Samudosky of JMSWoodSculpture.com

All other photos are from Ripley Entertainment Inc. Every attempt has been made to acknowledge correctly and contact copyright holders and we apologize in advance for any unintentional errors or omissions, which will be corrected in future editions.

LOCATIONS

Many of the art pieces found within this book can be seen at one of our Odditorium locations:

Australia
Surfers Paradise

California
Hollywood, San Francisco

Canada
Cavendish, P.E.I; Niagara Falls, Ontario

Denmark
Copenhagen

England
Blackpool

Florida
Key West, Orlando, Panama City Beach, St. Augustine

Korea
Jeju Island

Malaysia
Genting Highlands

Maryland
Baltimore, Ocean City

Mexico
Guadalajara, Mexico City, Veracruz

Missouri
Branson

The Netherlands
Amsterdam

New Jersey
Atlantic City

New York
New York City

Oregon
Newport

South Carolina
Myrtle Beach

Tennessee
Gatlinburg

Texas
Grand Prairie, San Antonio

Thailand
Pattaya

Virginia
Williamsburg

Wisconsin
Wisconsin Dells

www.ripleys.com